ADULT COLORING

TODD McFARLANE

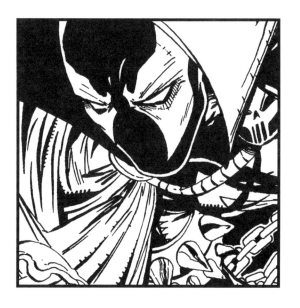
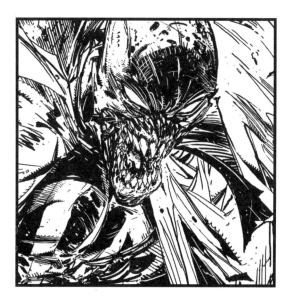
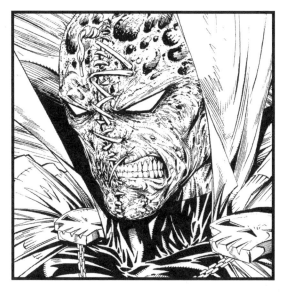
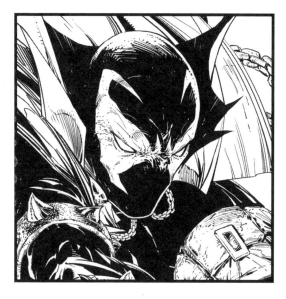

Art by **TODD McFARLANE**

Pencil drawing on pages 7 and 19 by **ERIK LARSEN**

Layout drawing on page 81 by **ROB LIEFELD**

Pencil drawing on page 91 by **WHILCE PORTACIO**

Cover art by **ERIK LARSEN** and **TODD McFARLANE**

Publishing Coordinator **SHANNON BAILEY**

Art Director **BEN TIMMRECK**

Publisher for Image Comics **ERIC STEPHENSON**

SPAWN CREATED BY
TODD McFARLANE

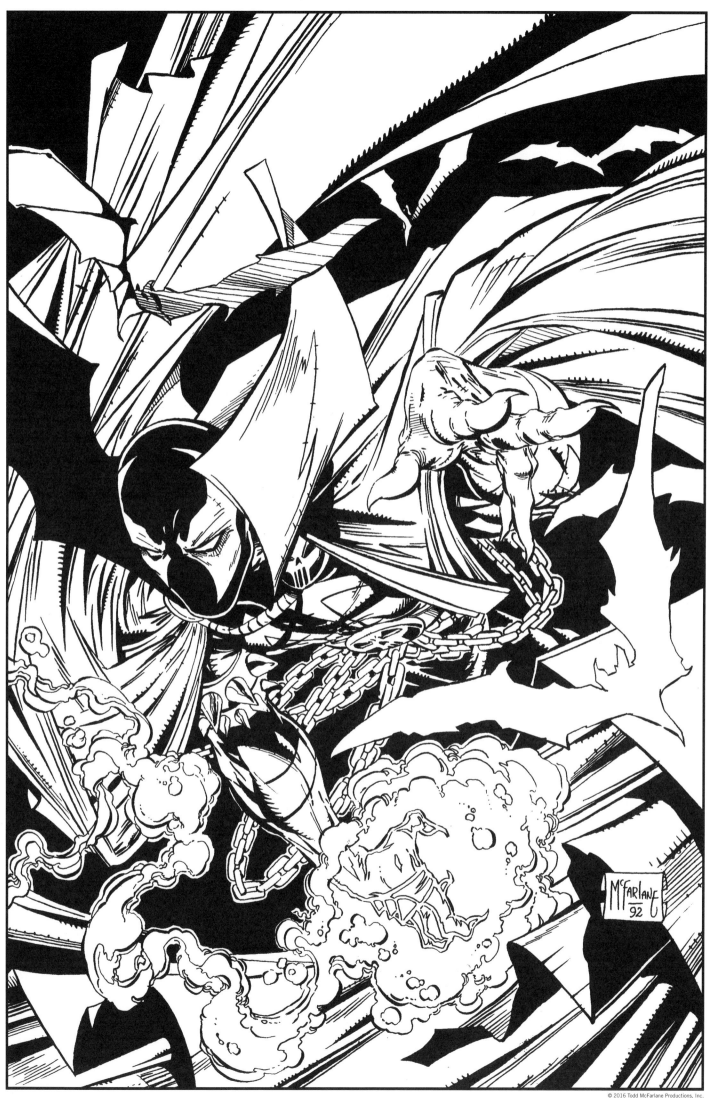

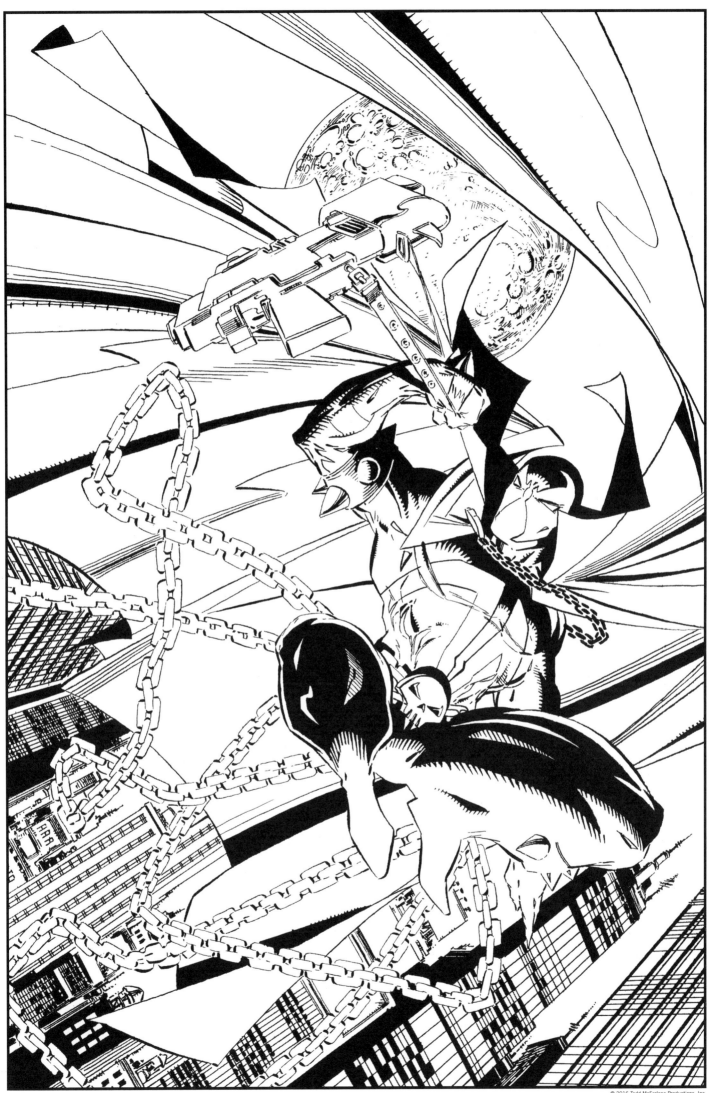

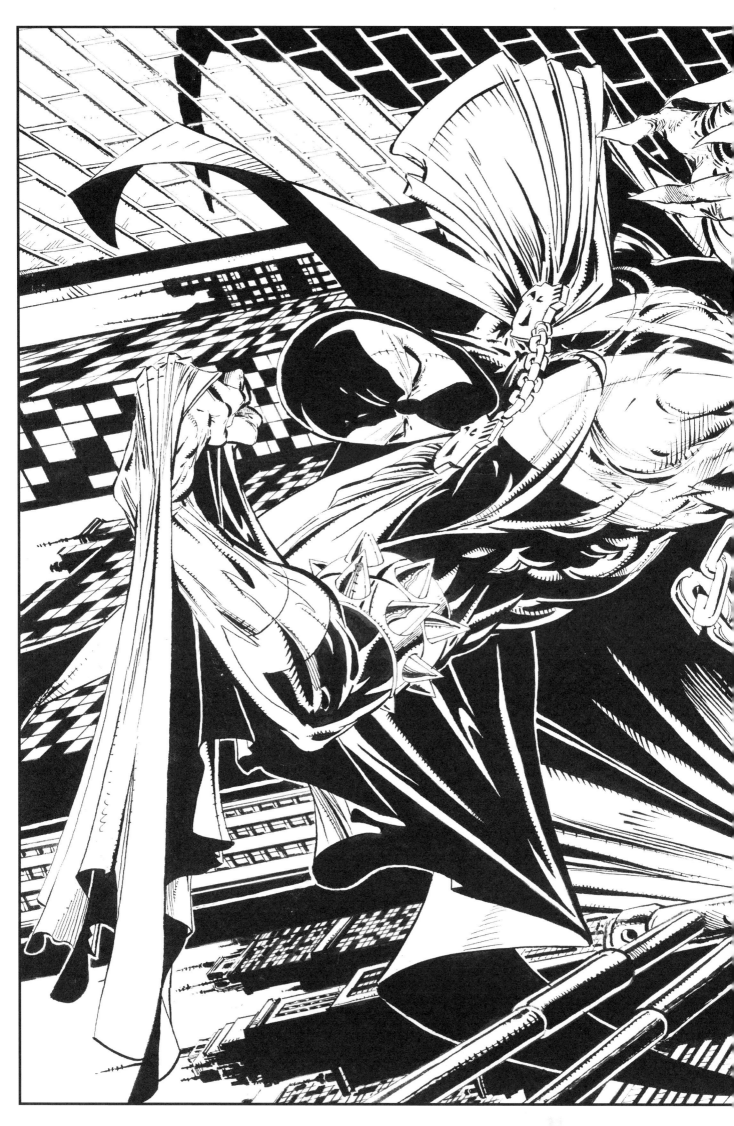

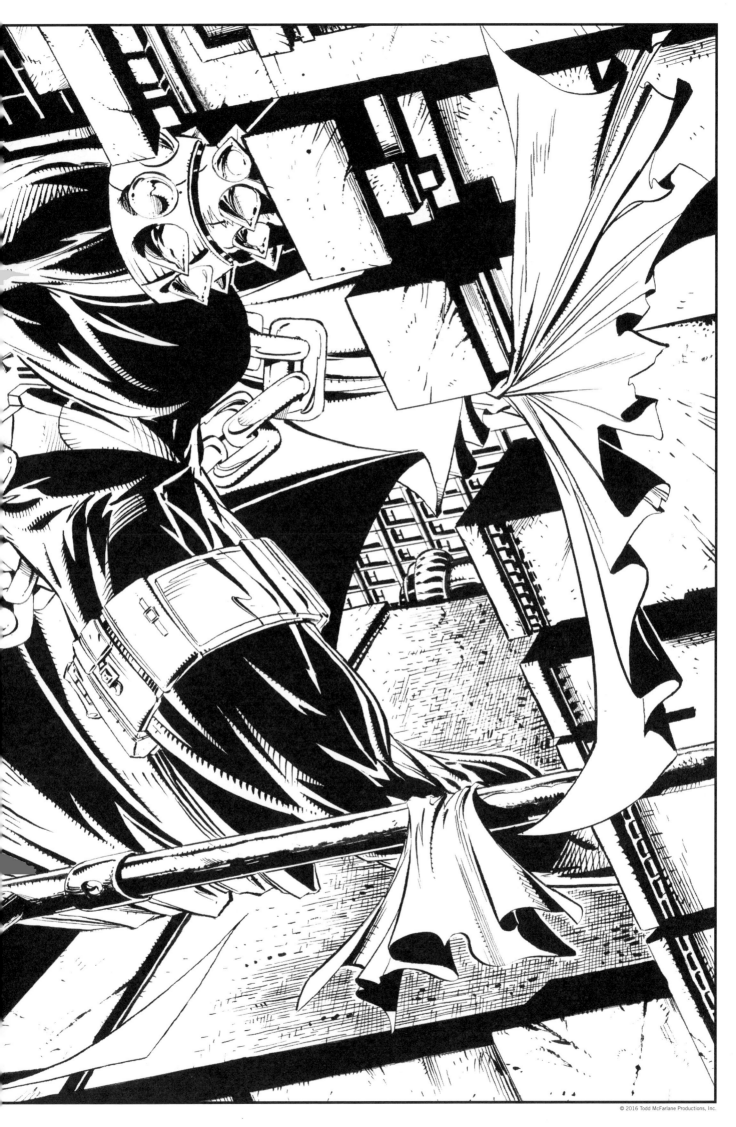

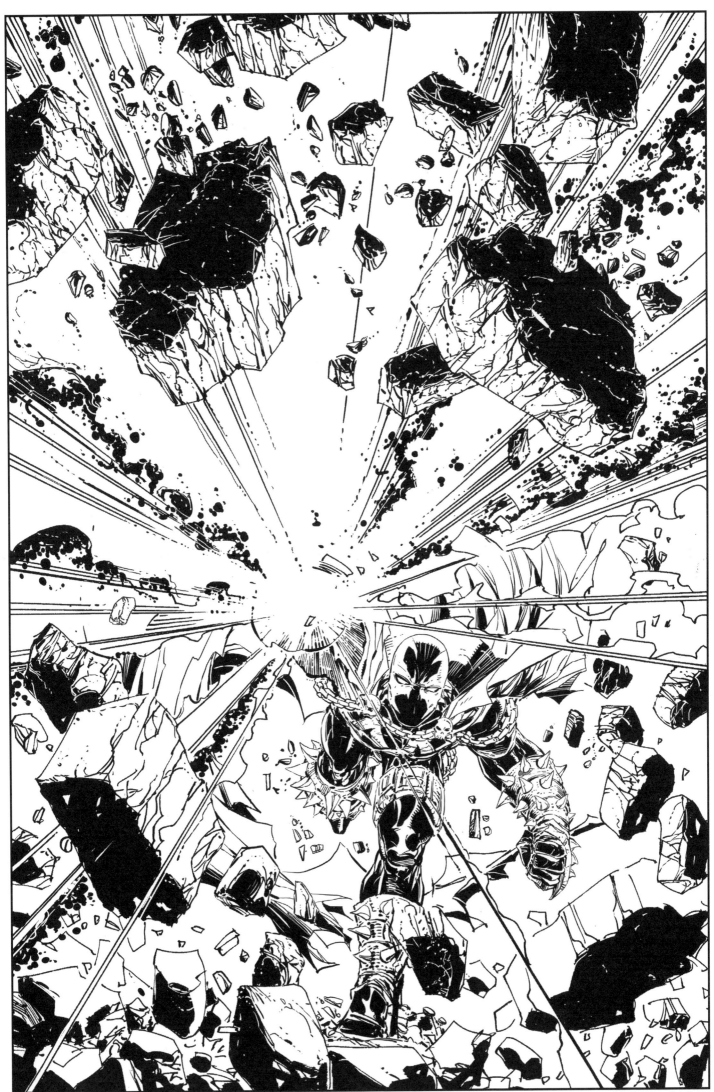

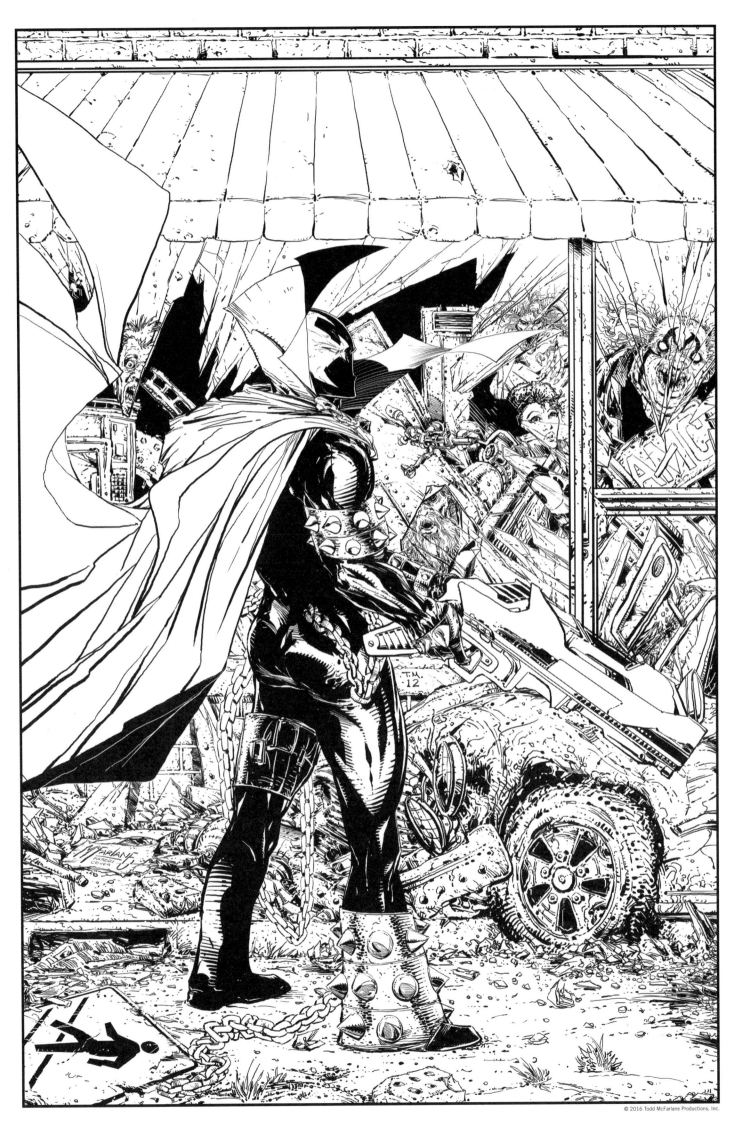

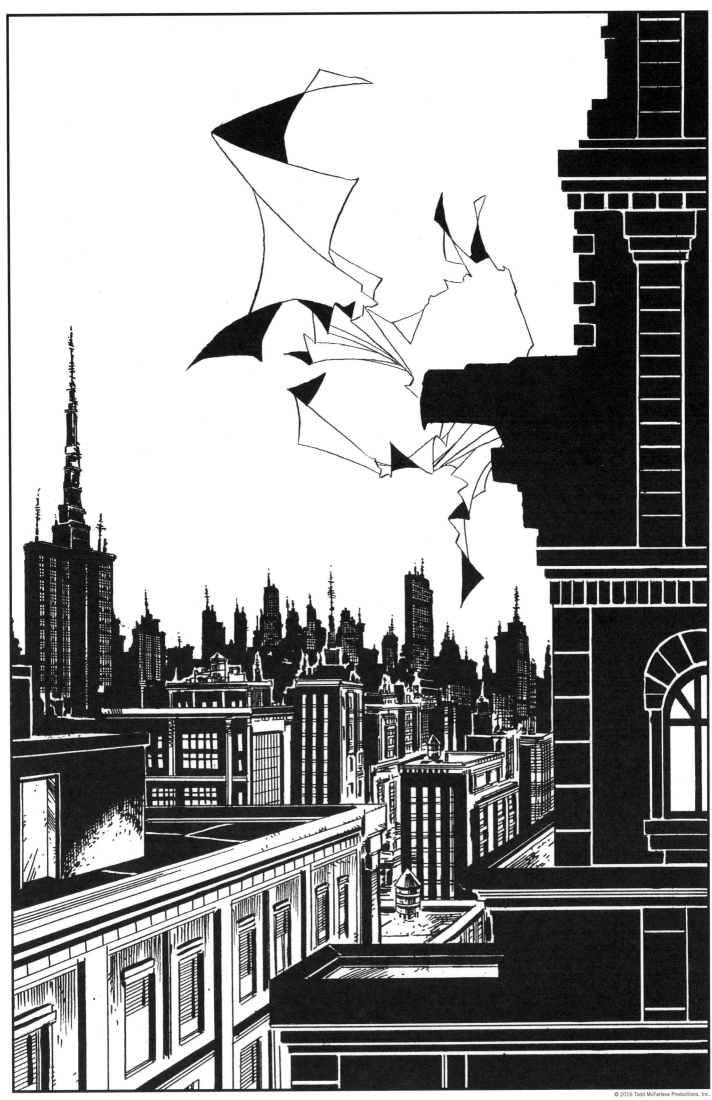

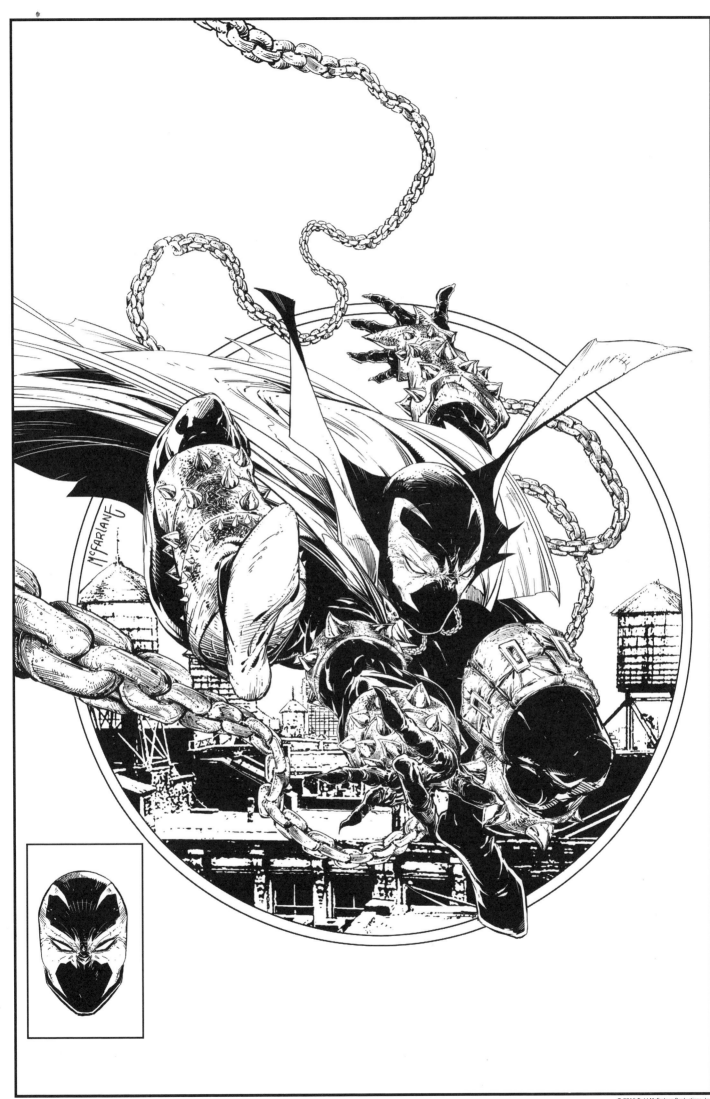

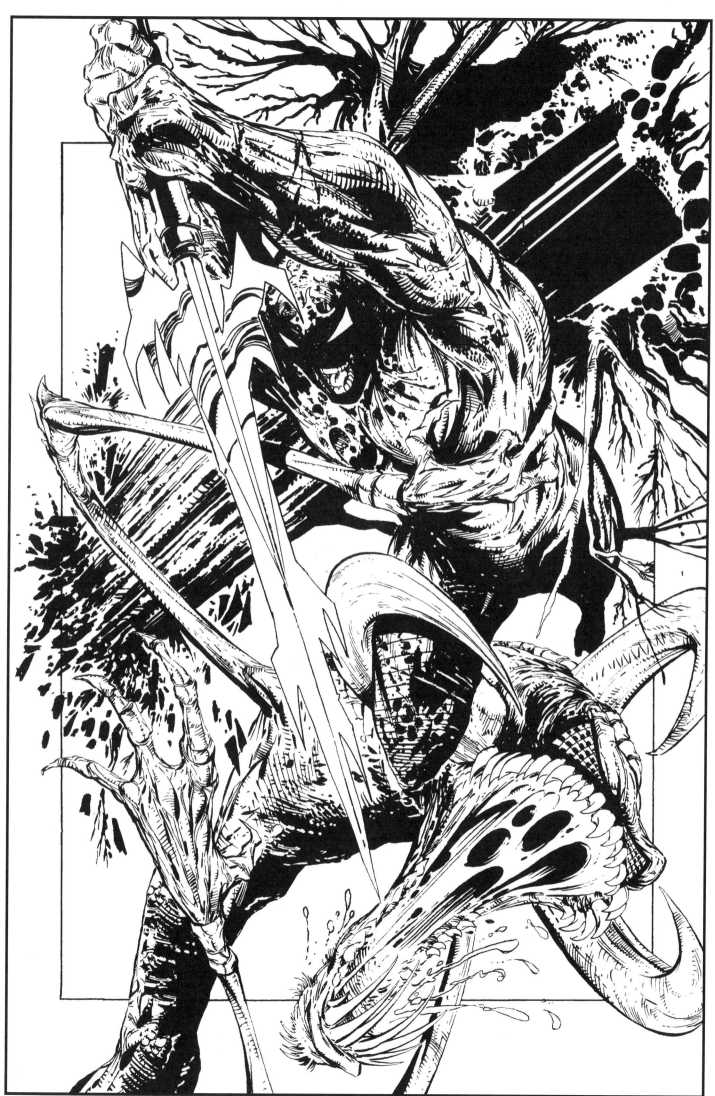

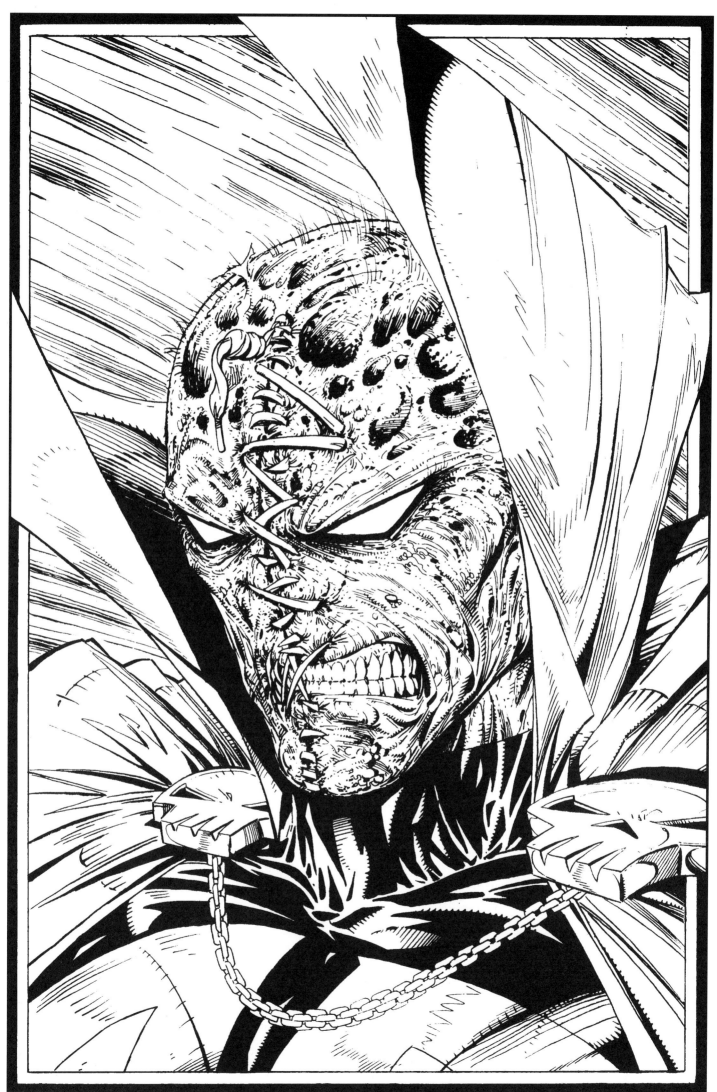

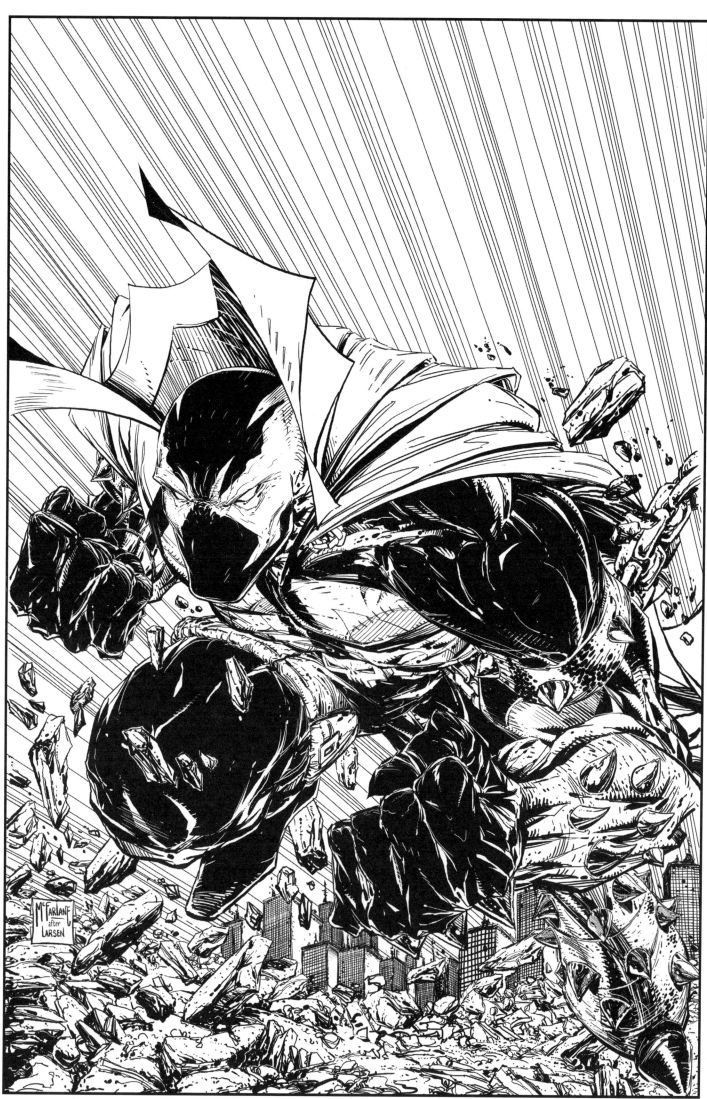

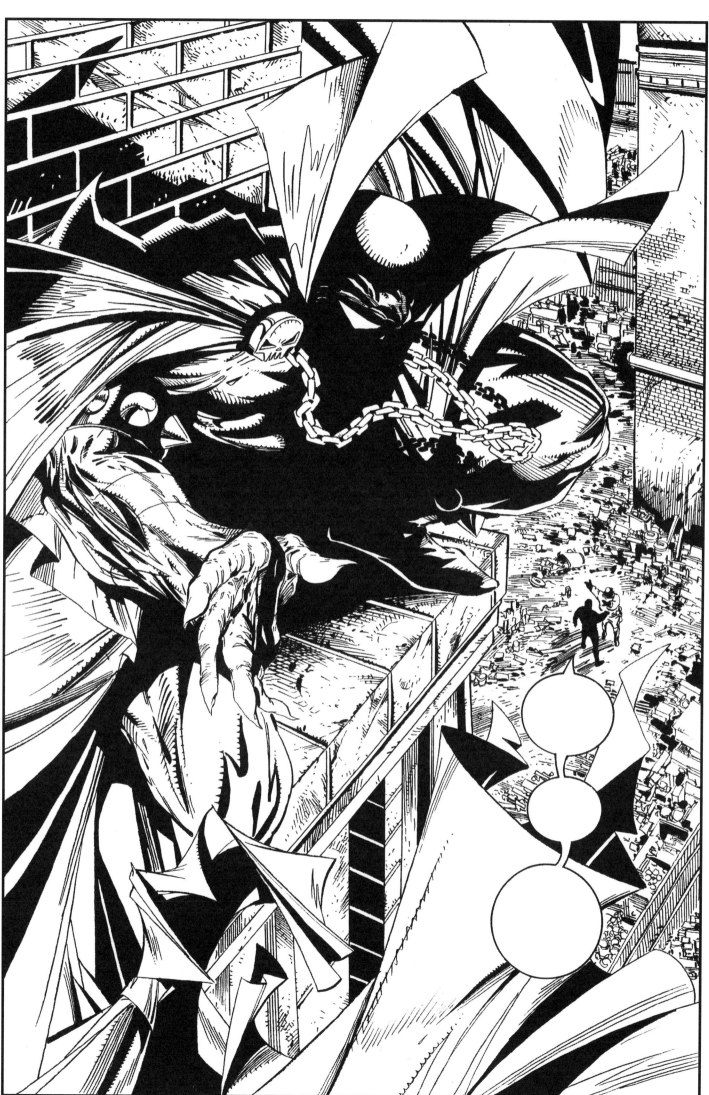

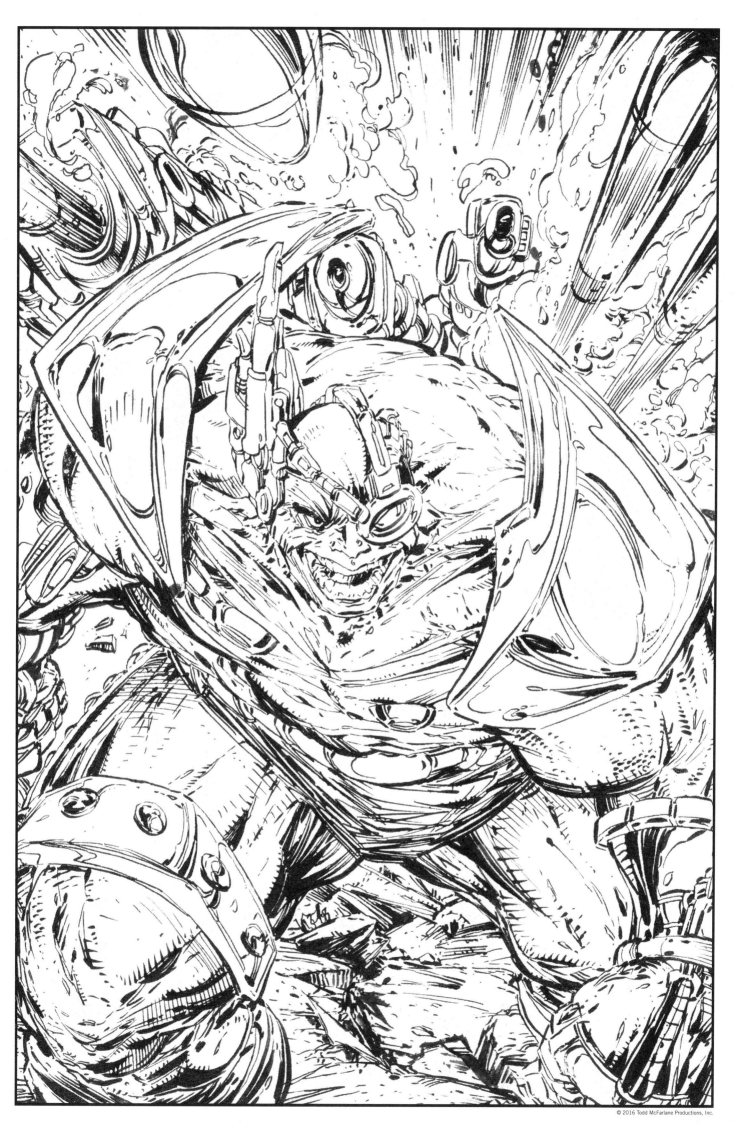

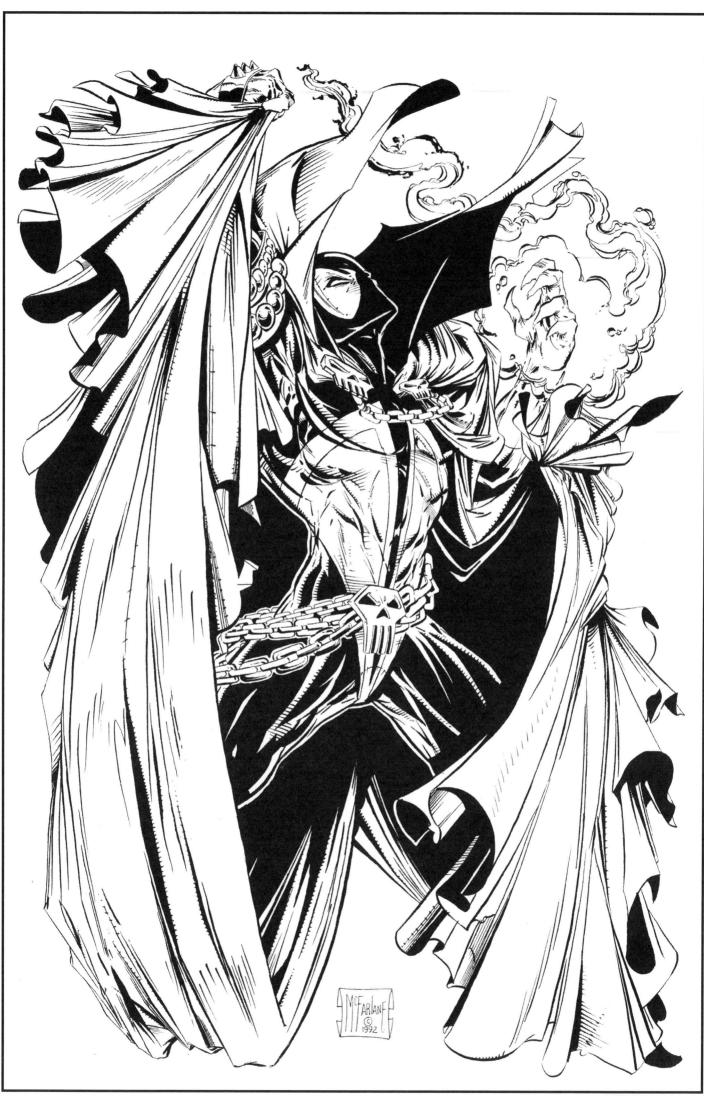

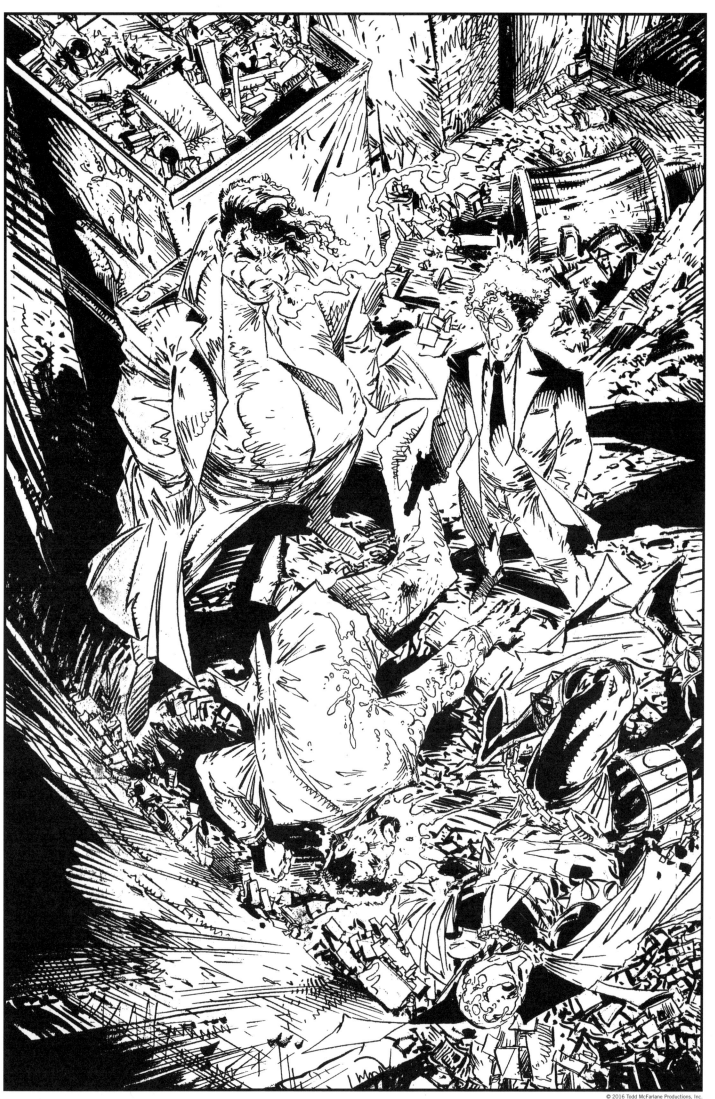

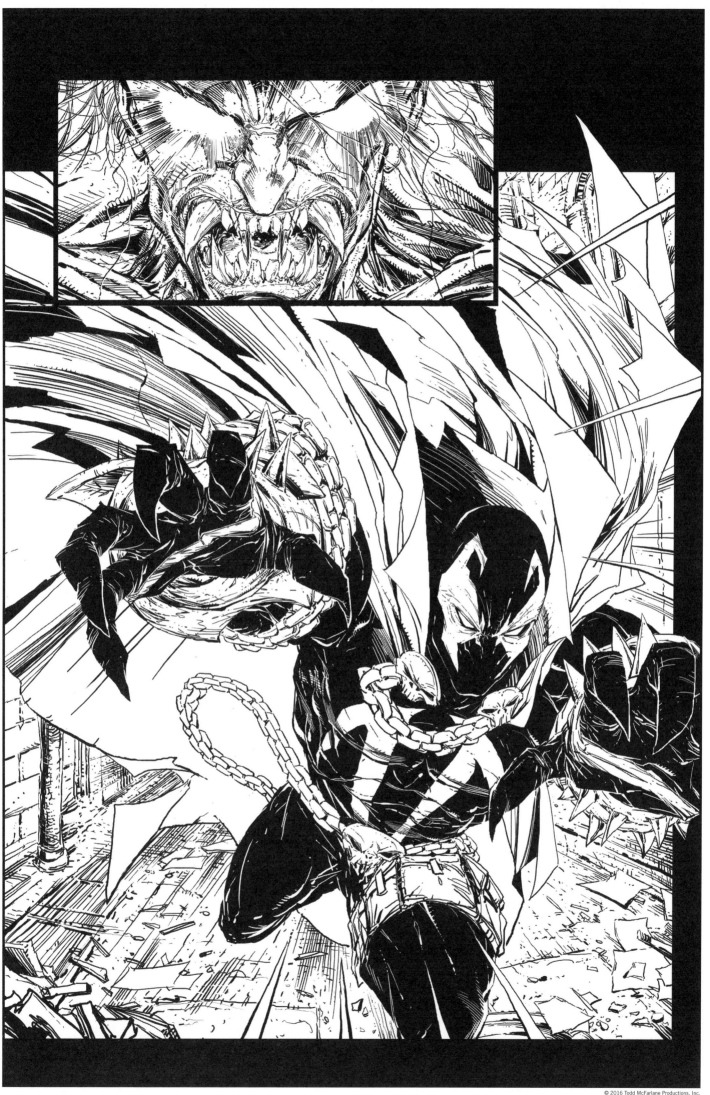

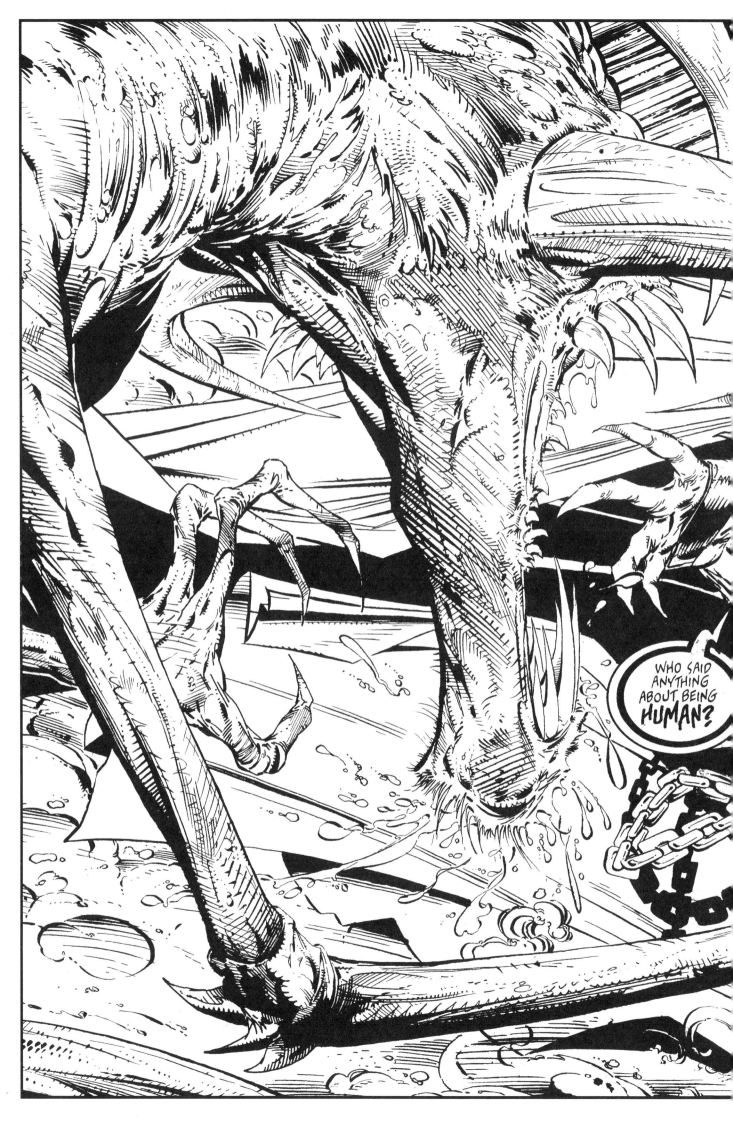

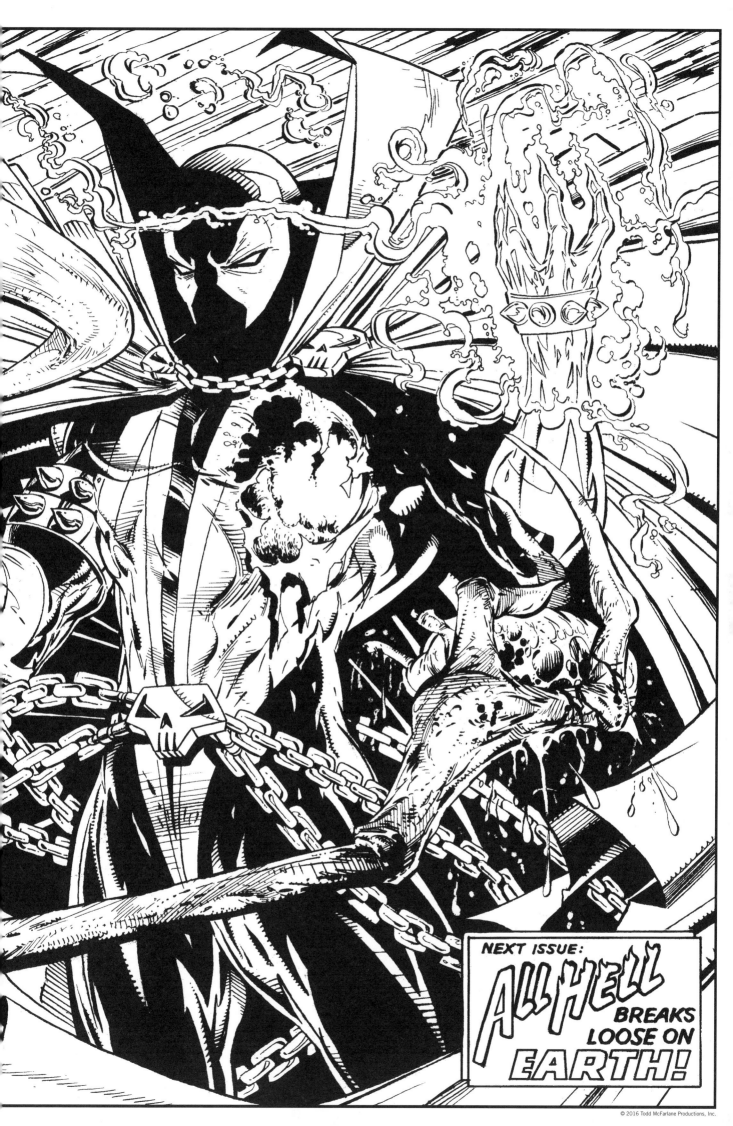

NEXT ISSUE: ALL HELL BREAKS LOOSE ON EARTH!

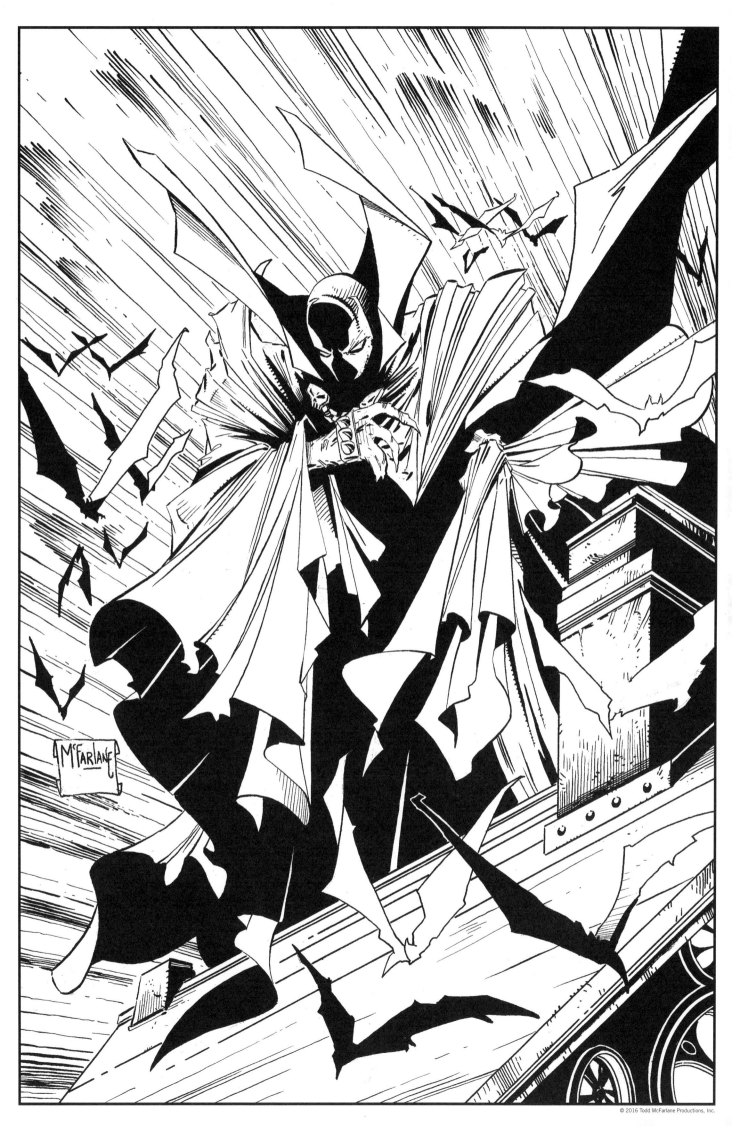

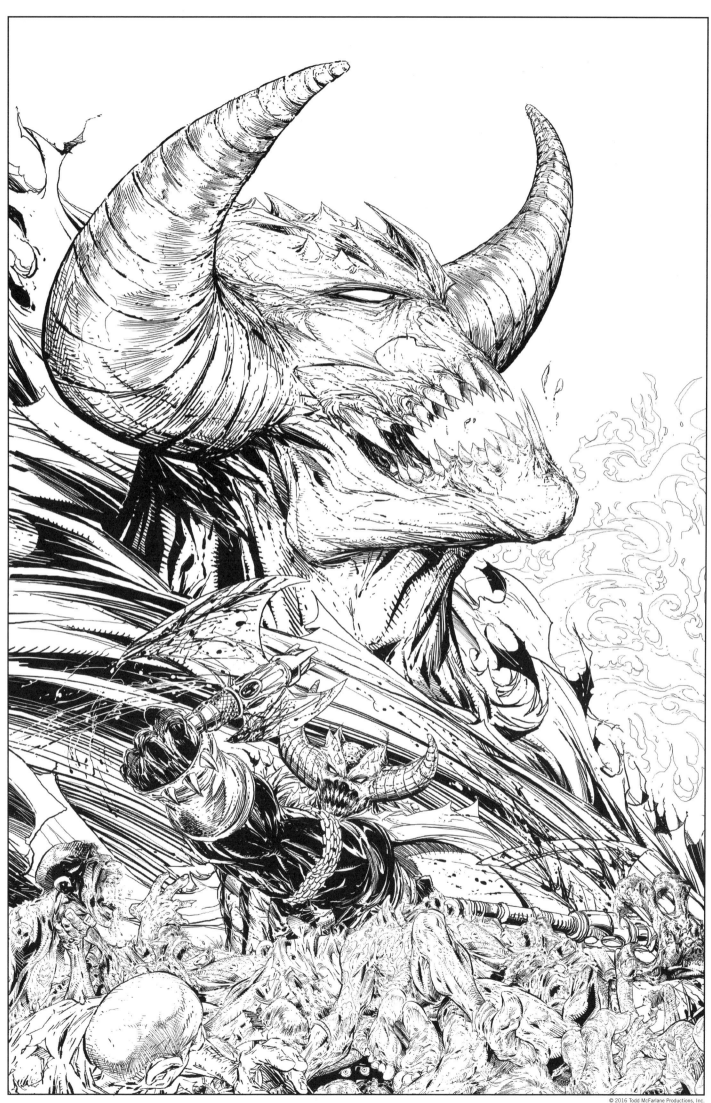

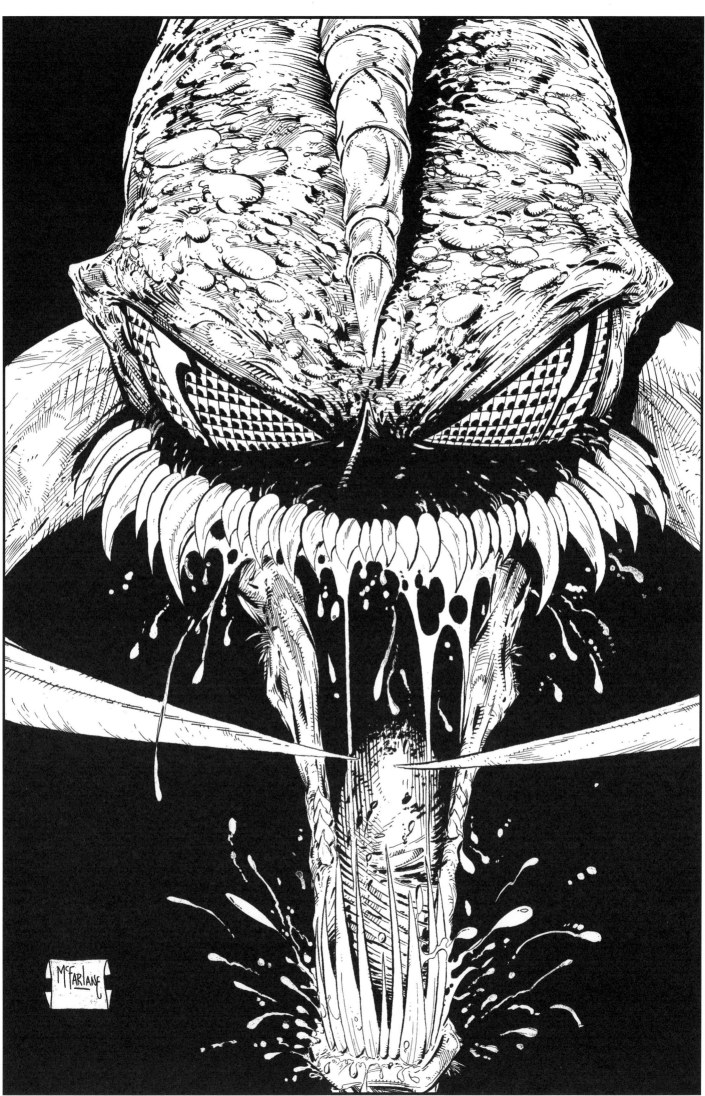

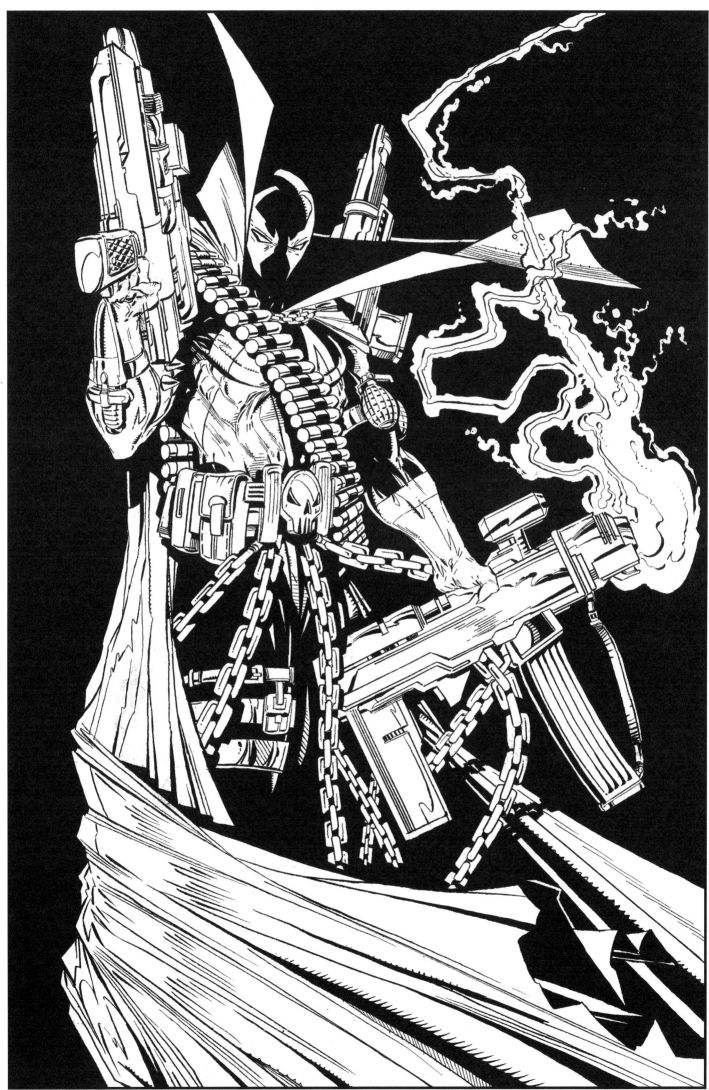

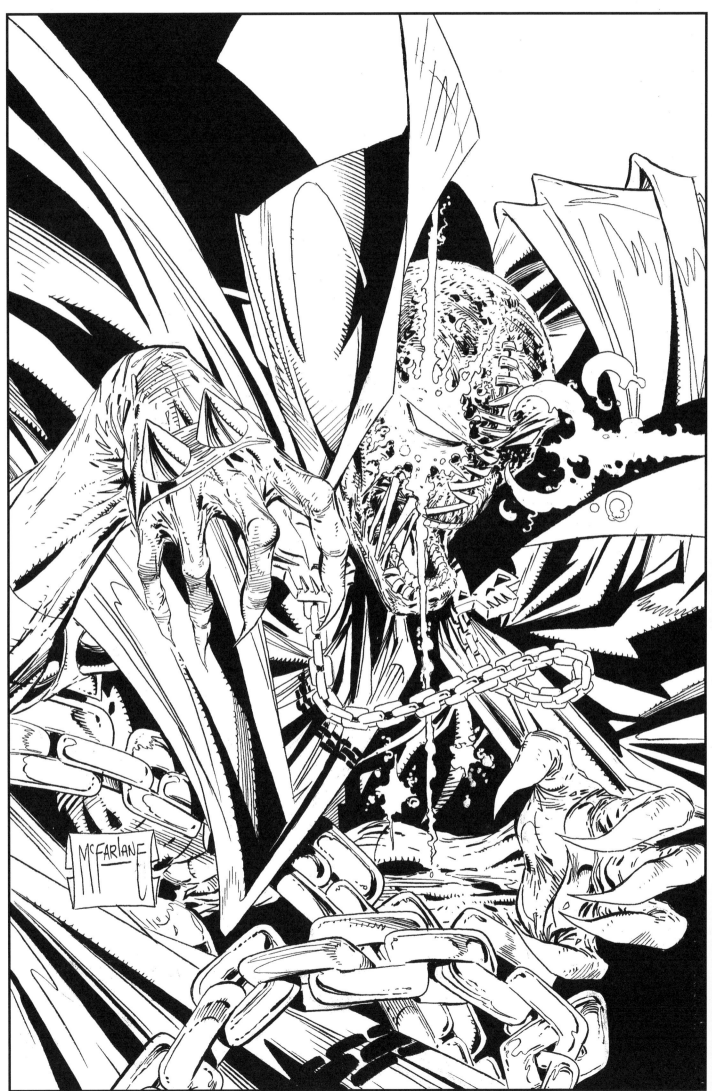

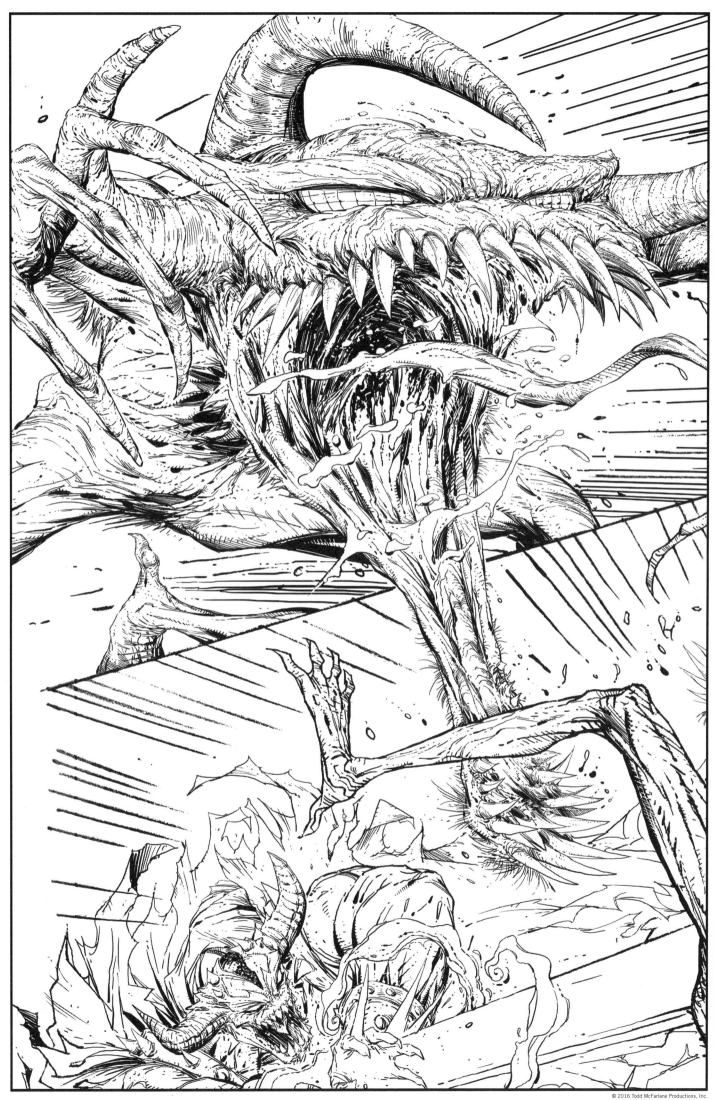

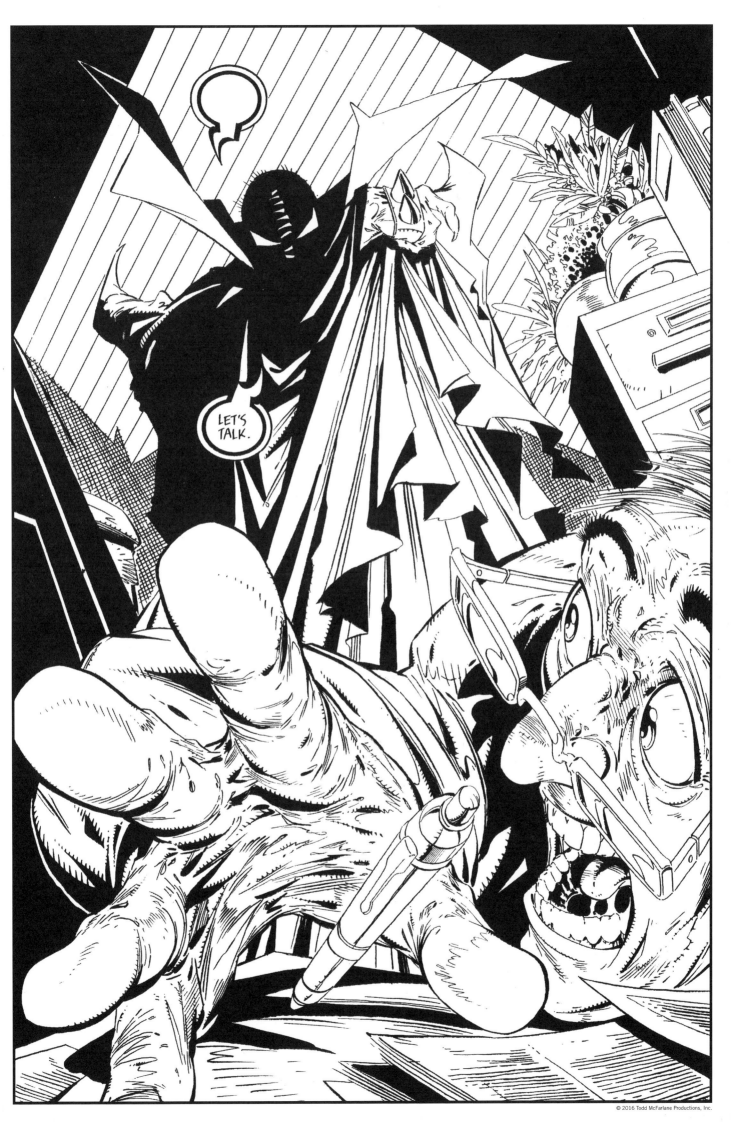

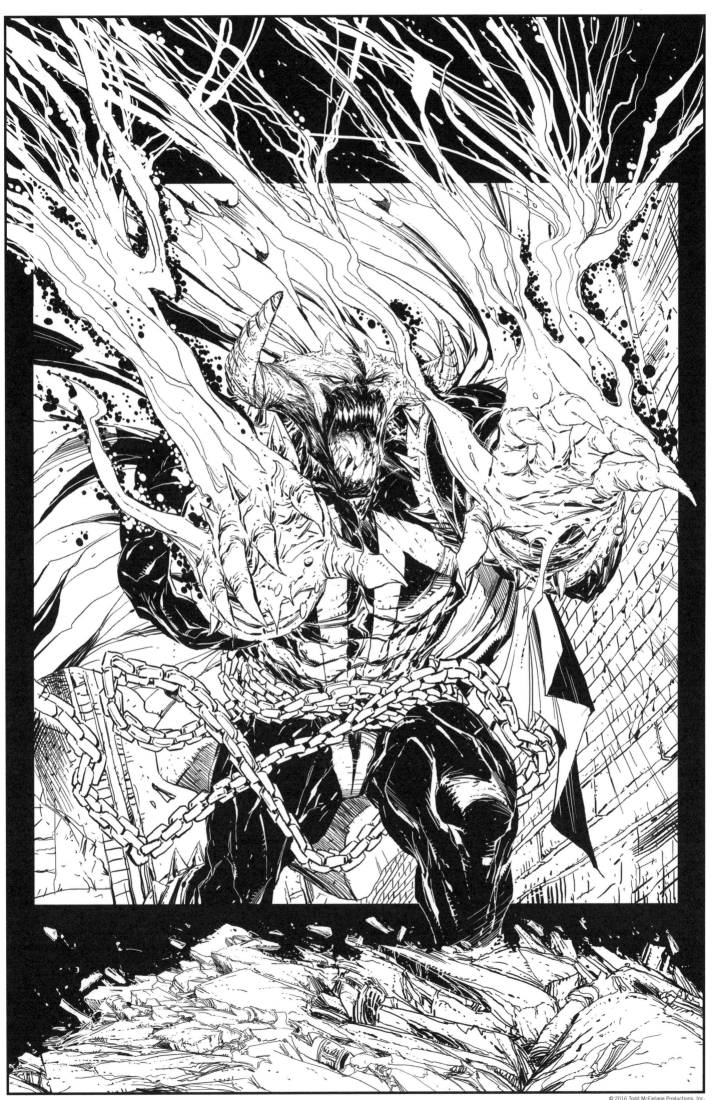

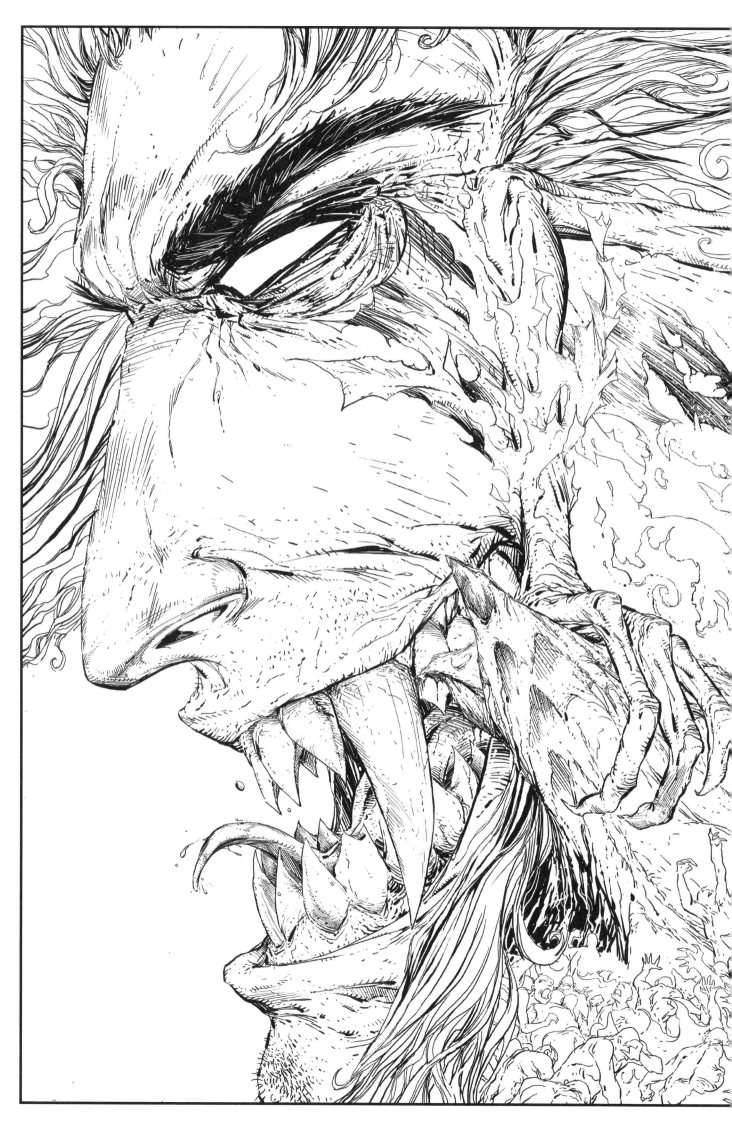

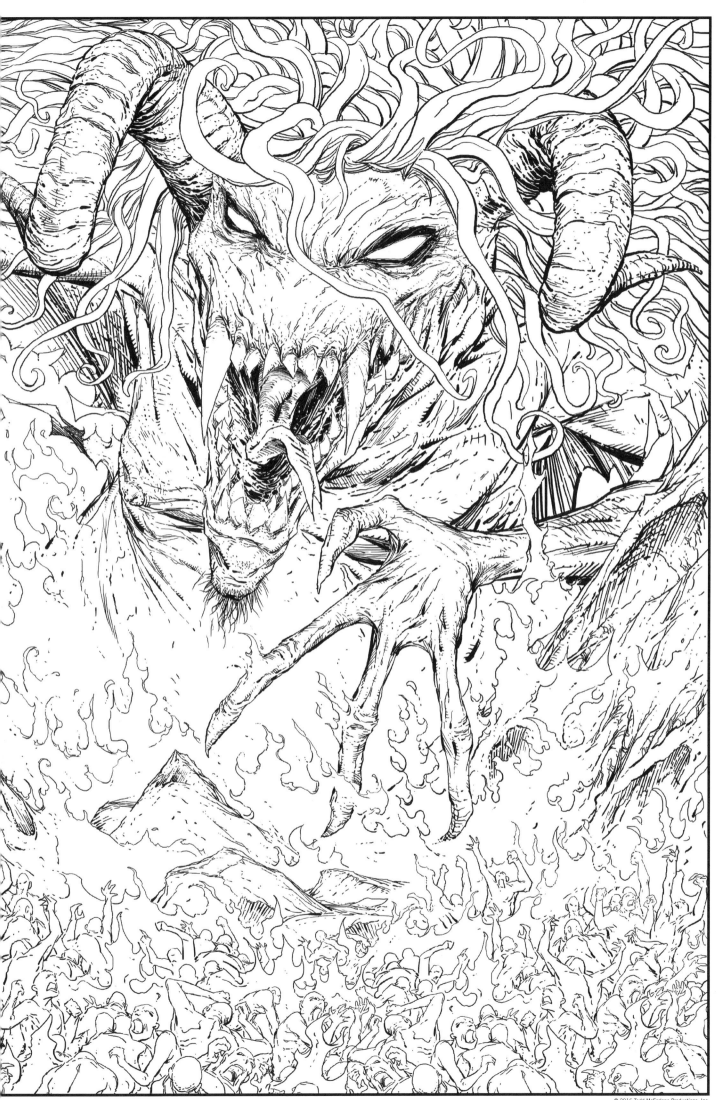

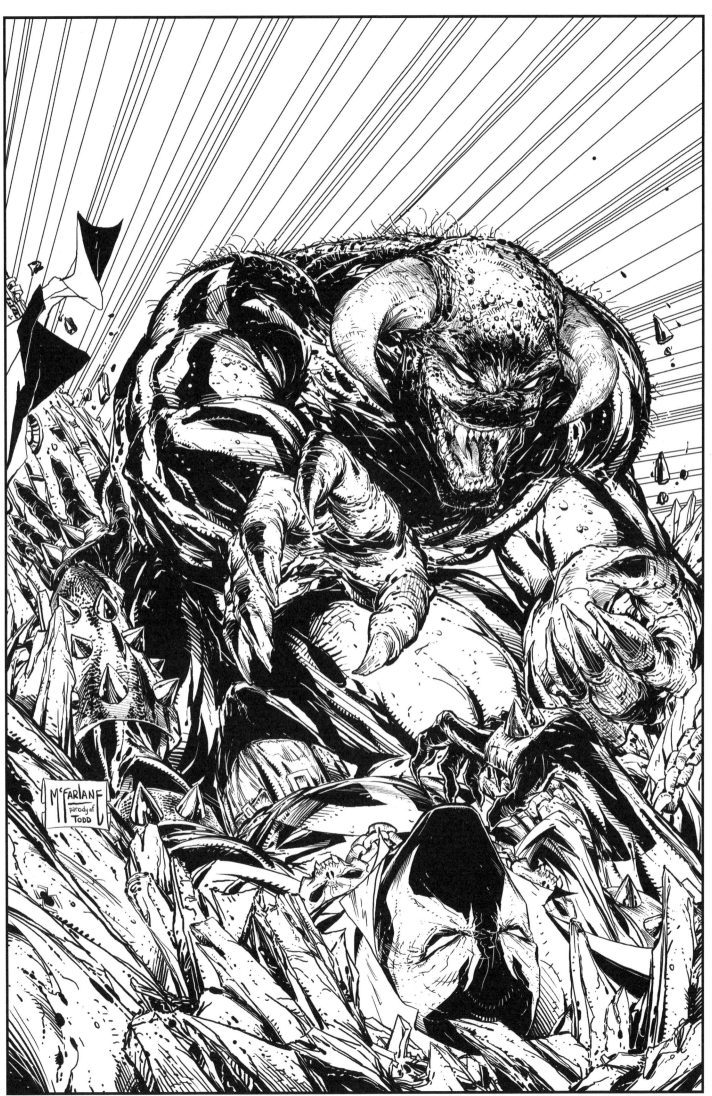

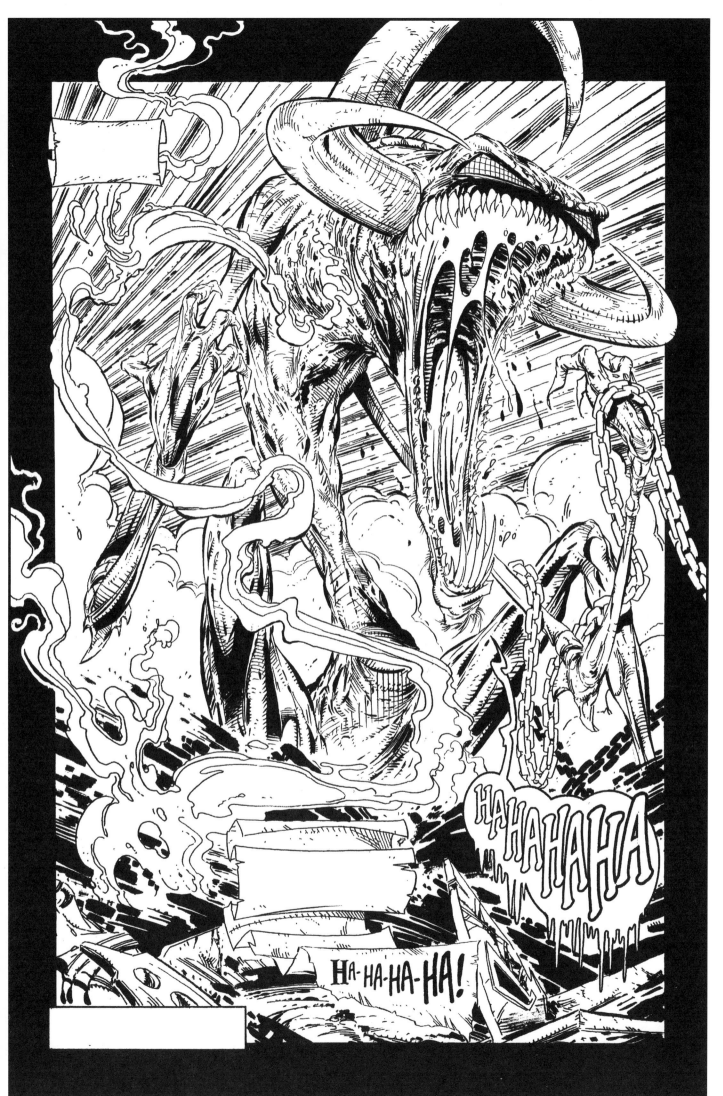

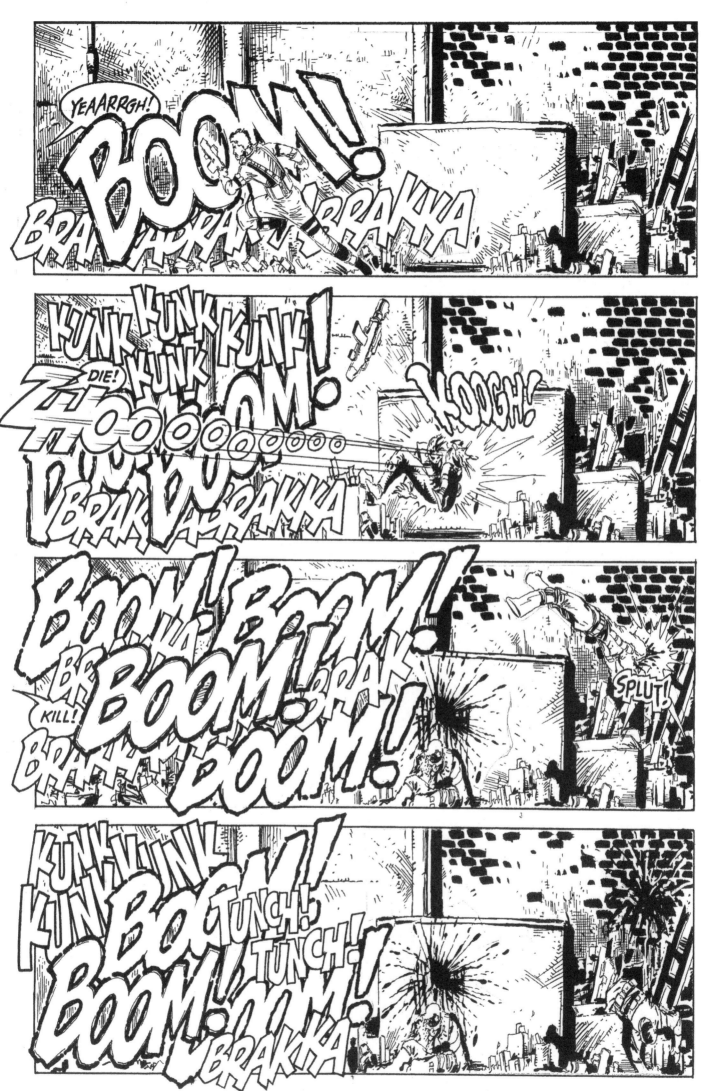

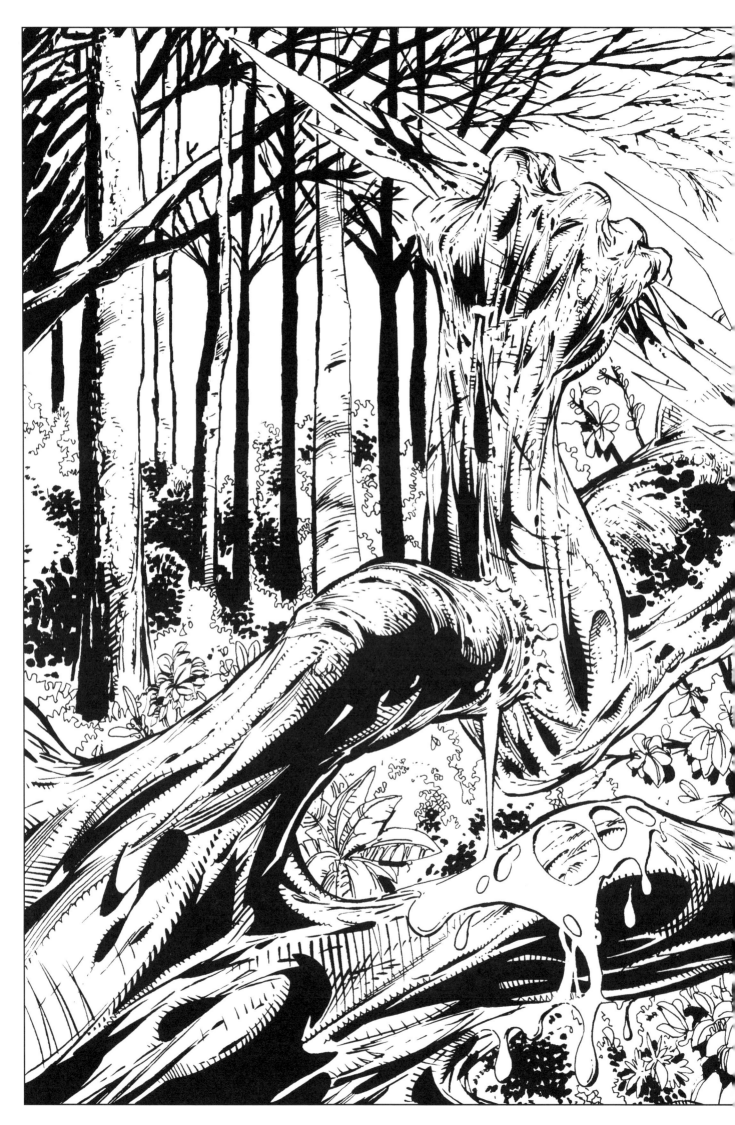

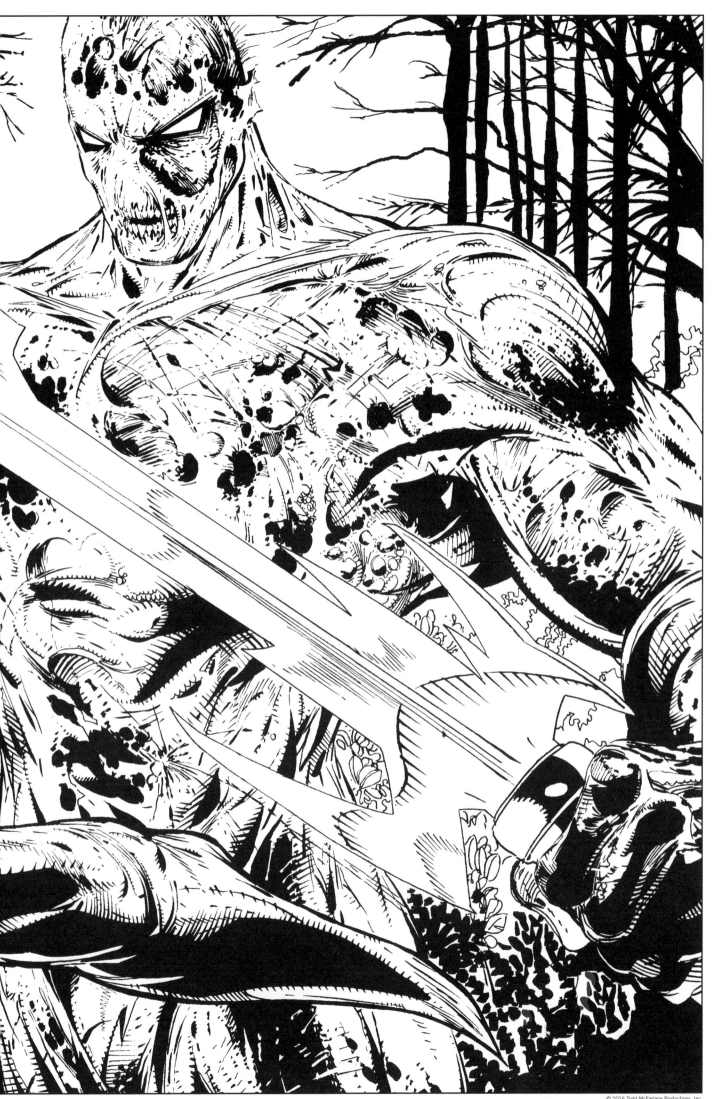

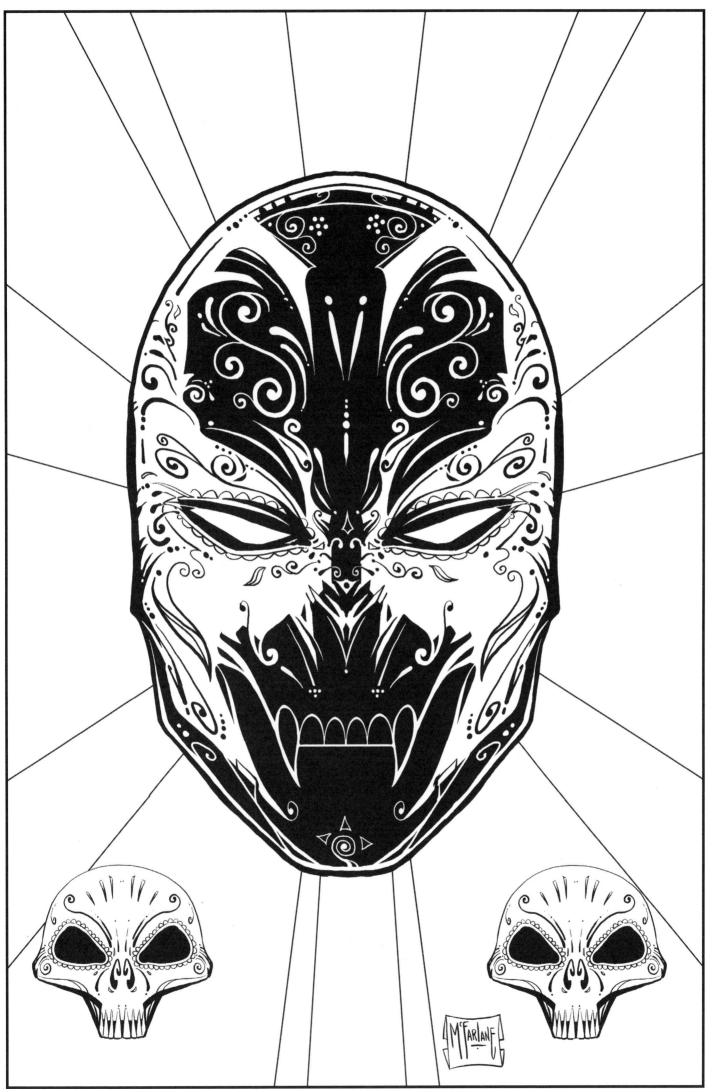

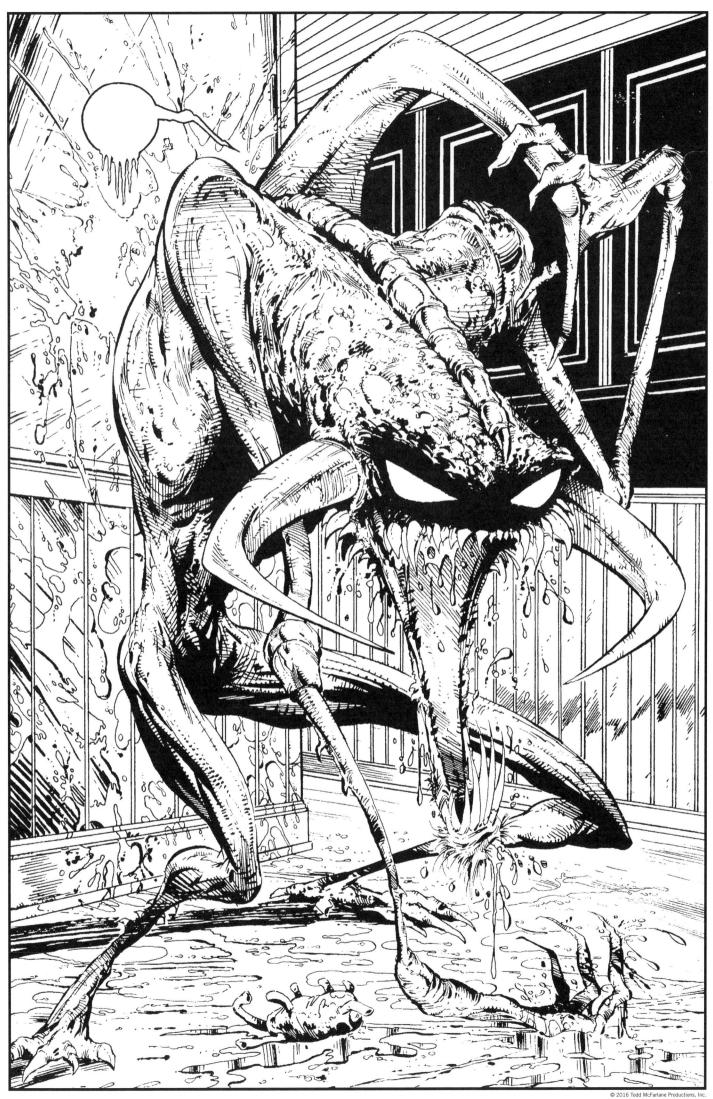

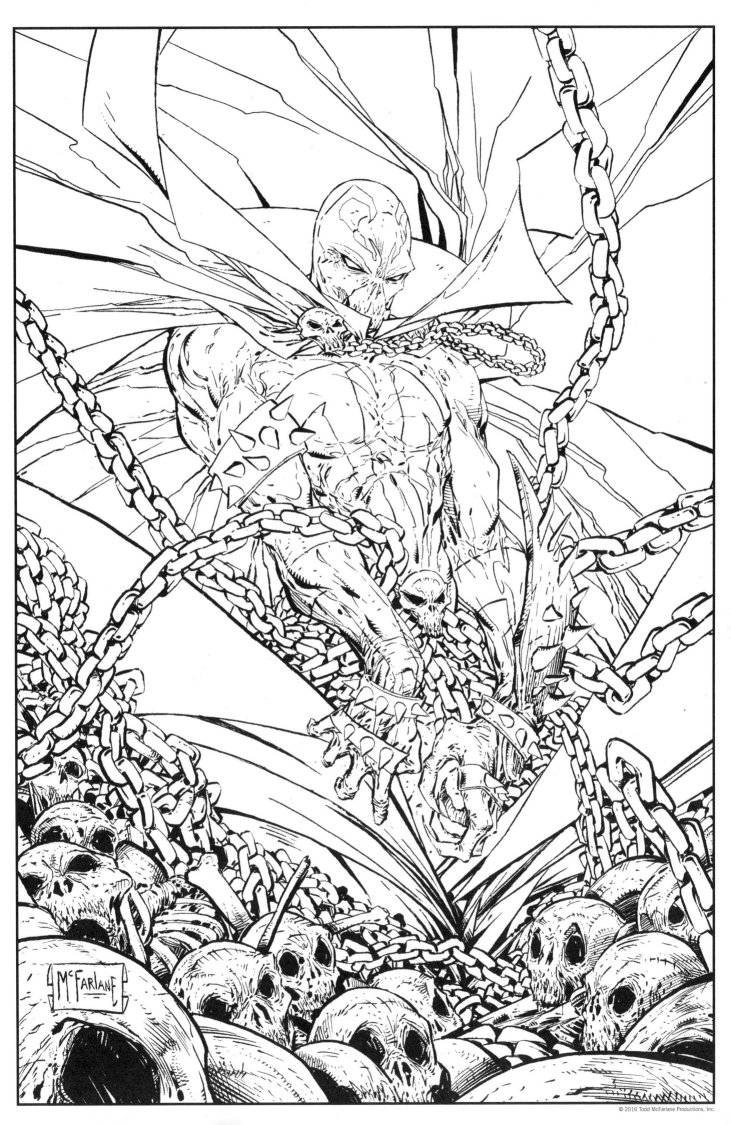

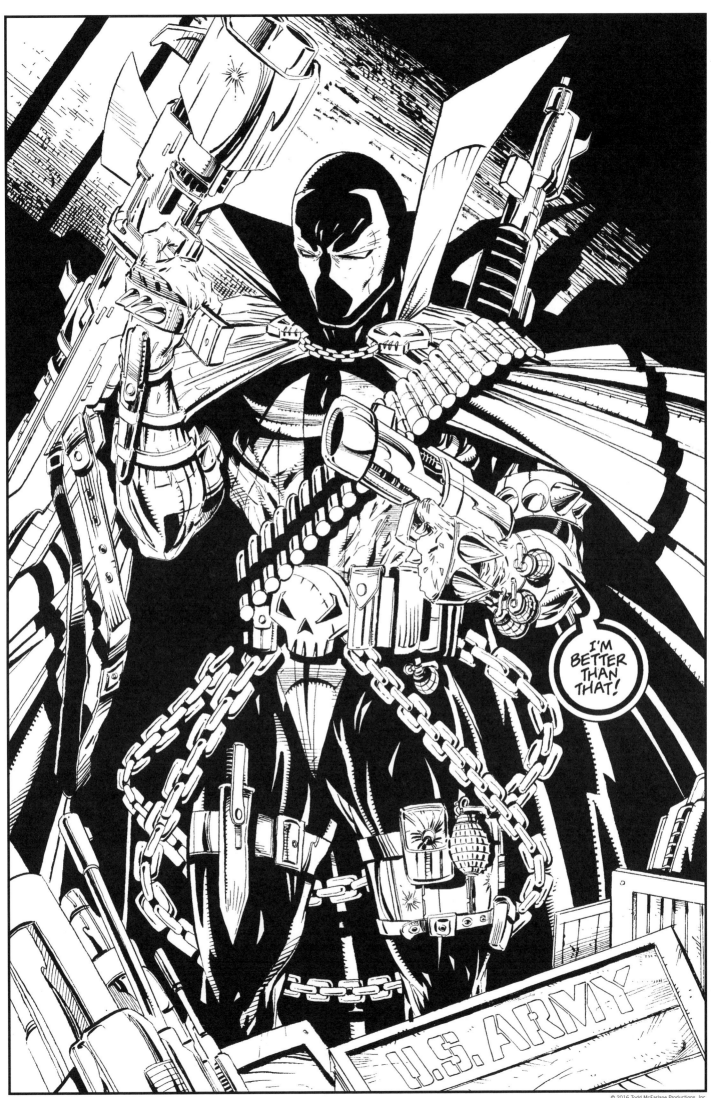

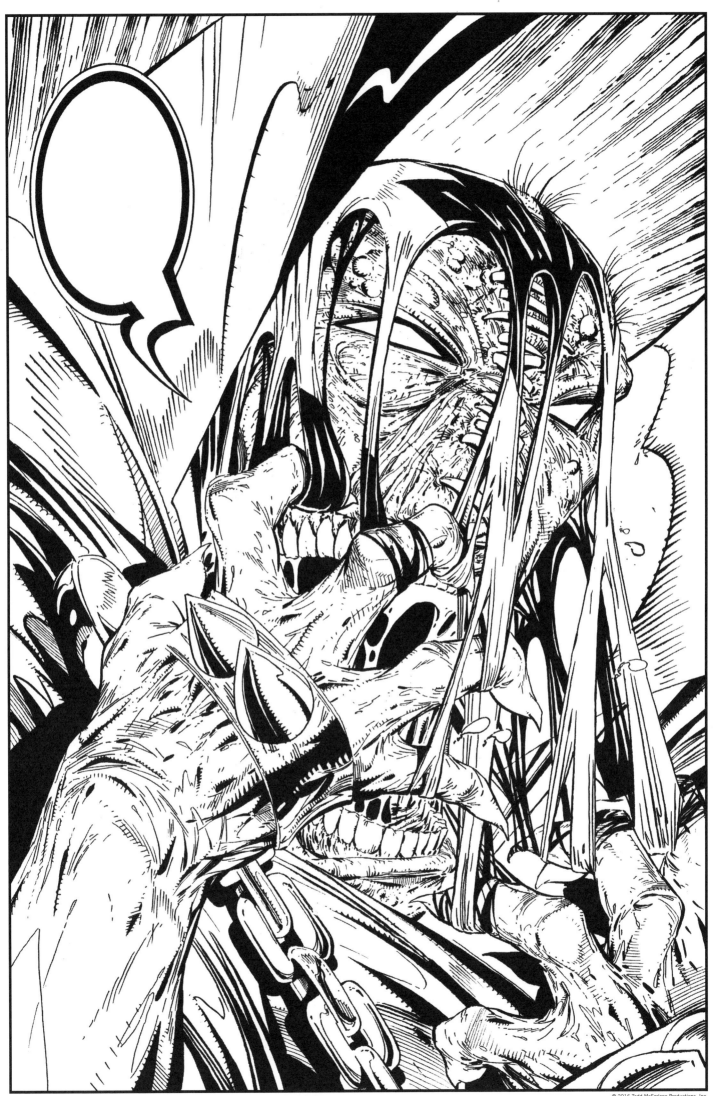

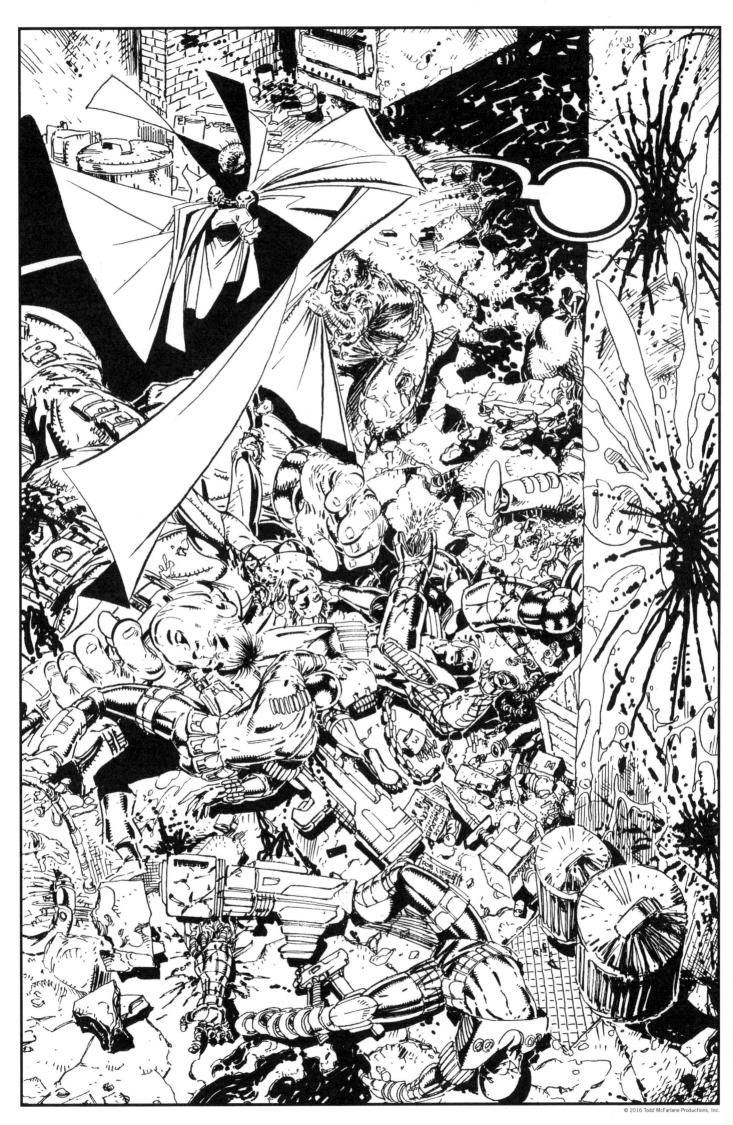

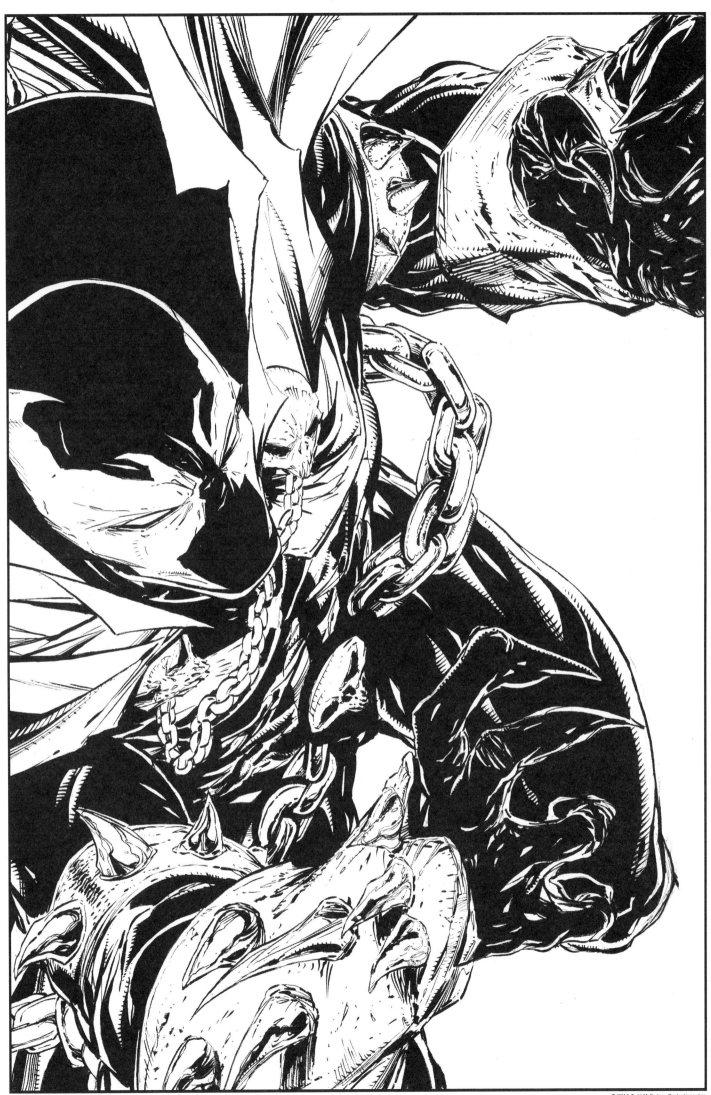

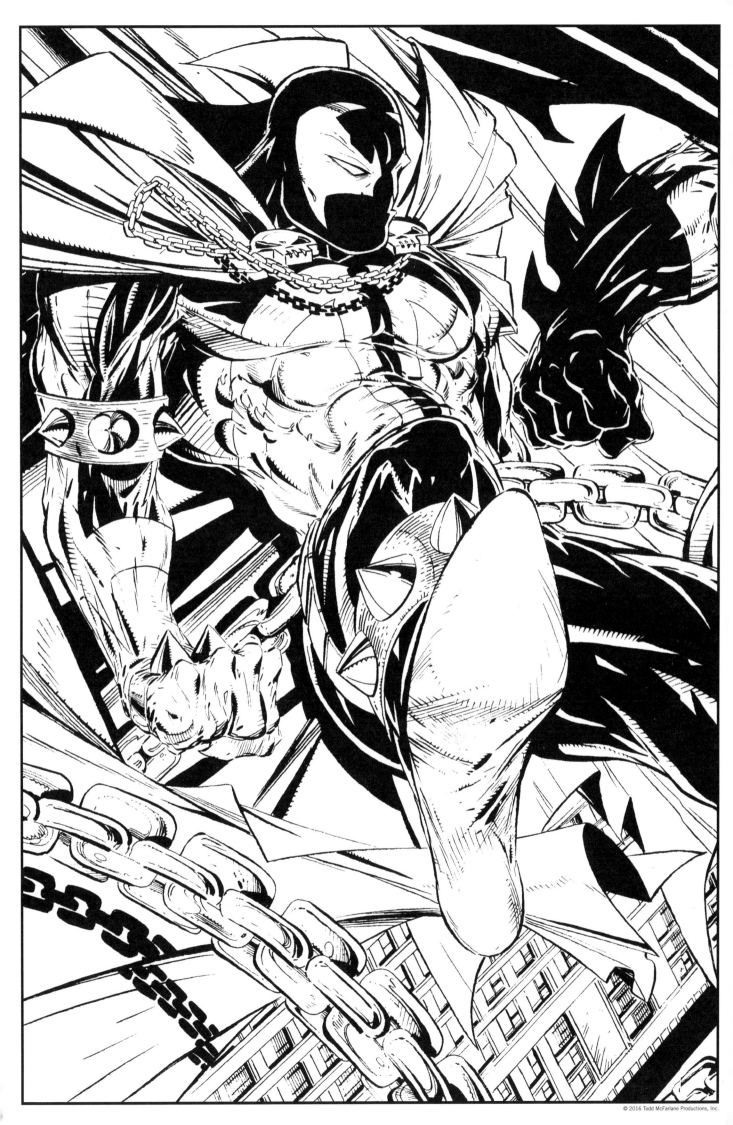

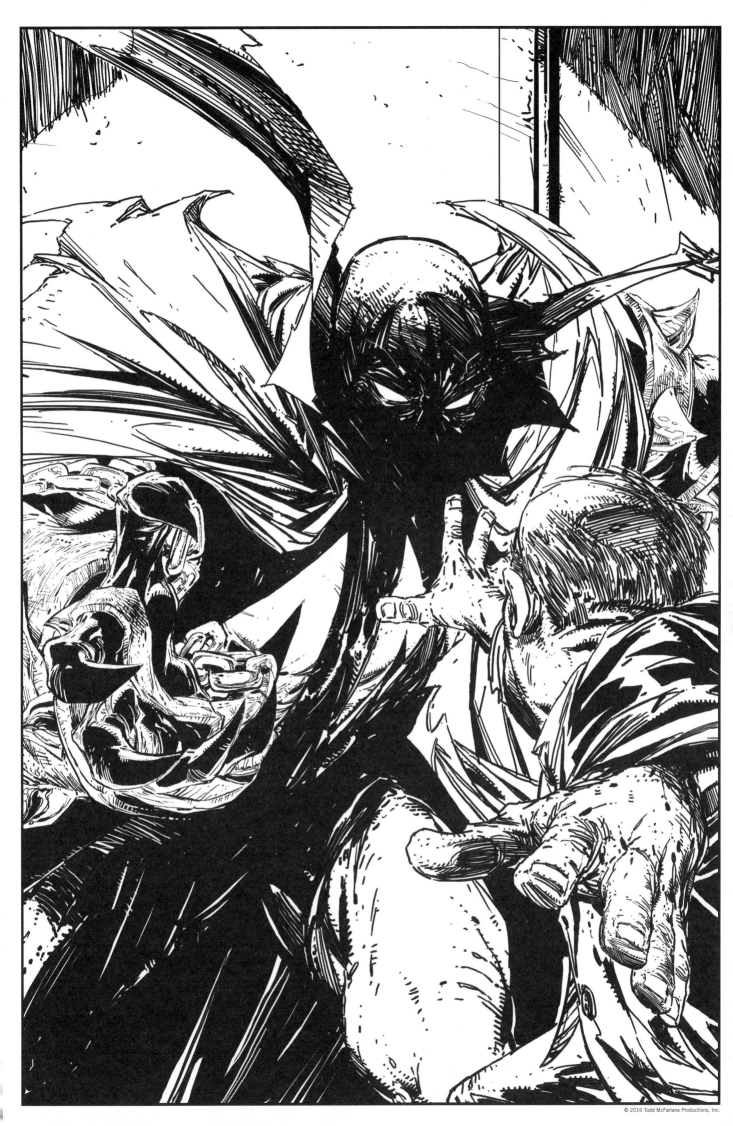

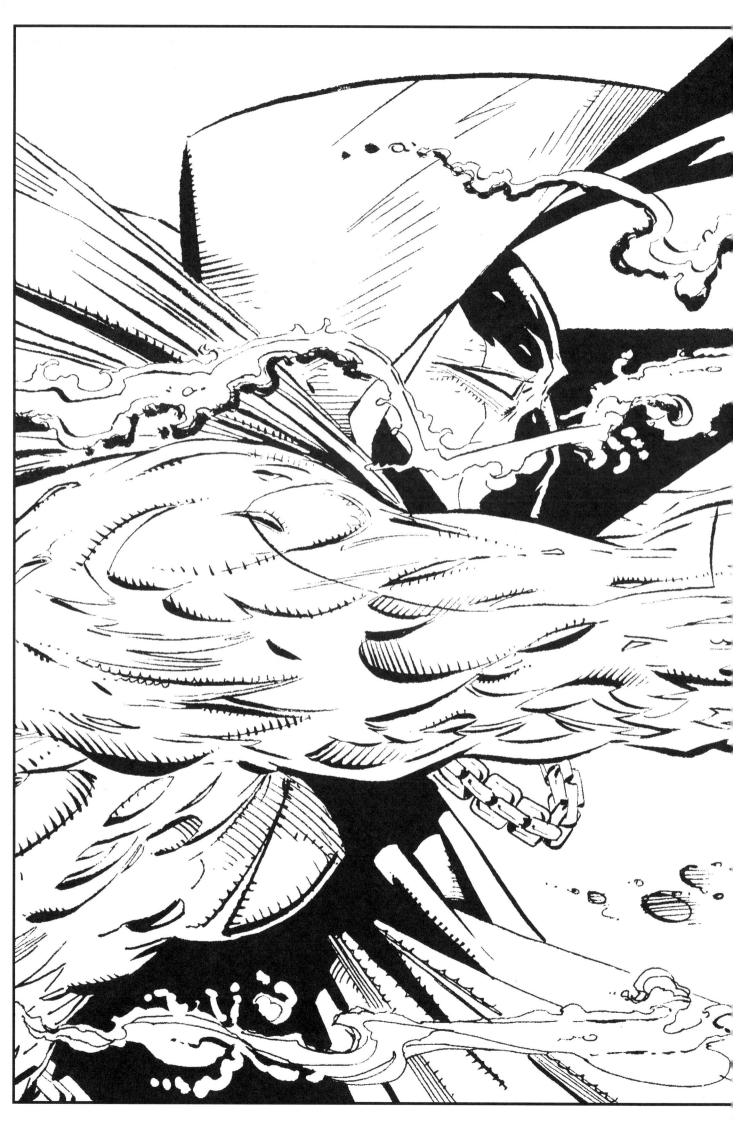

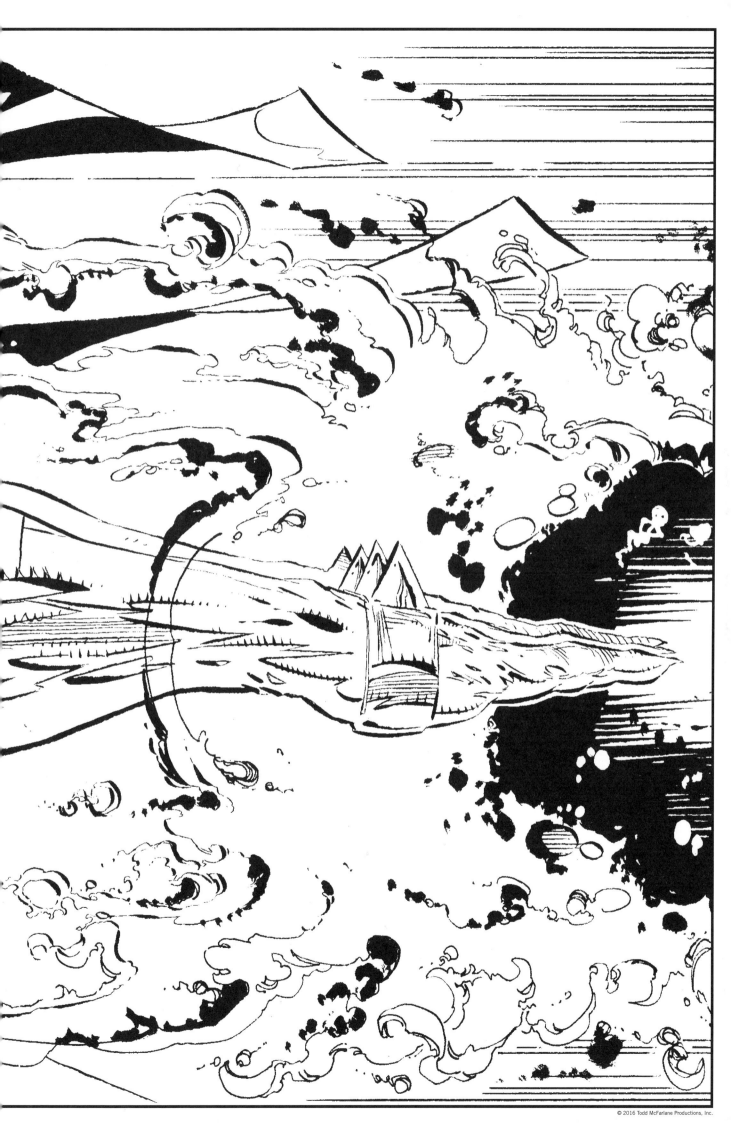

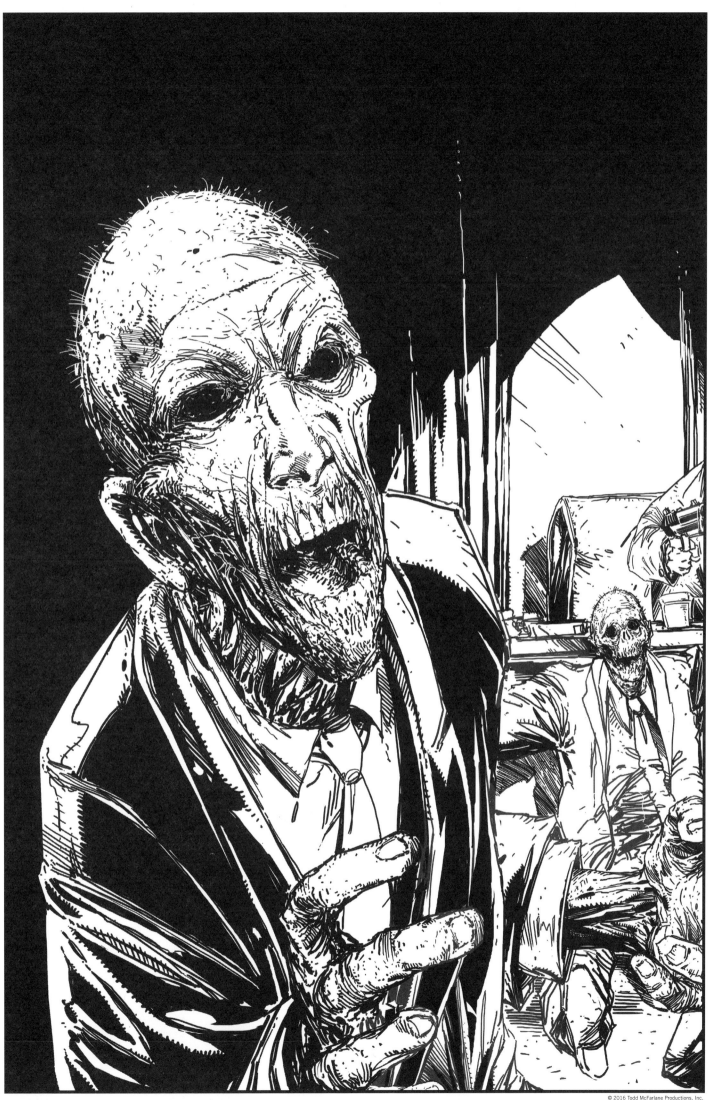

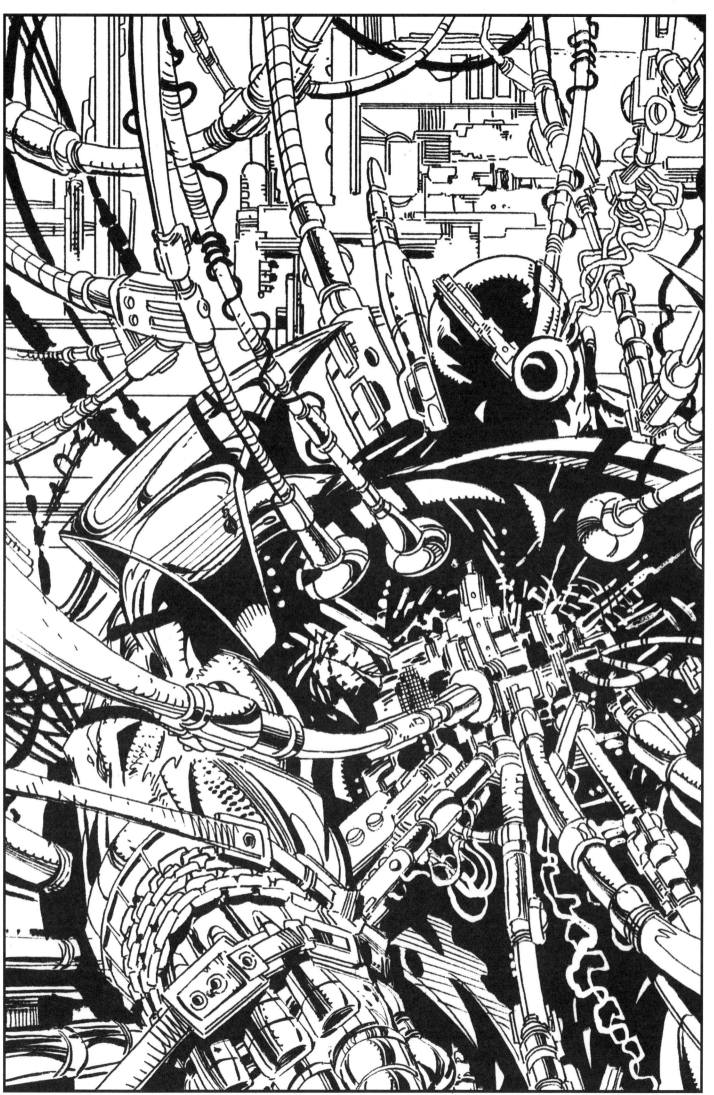

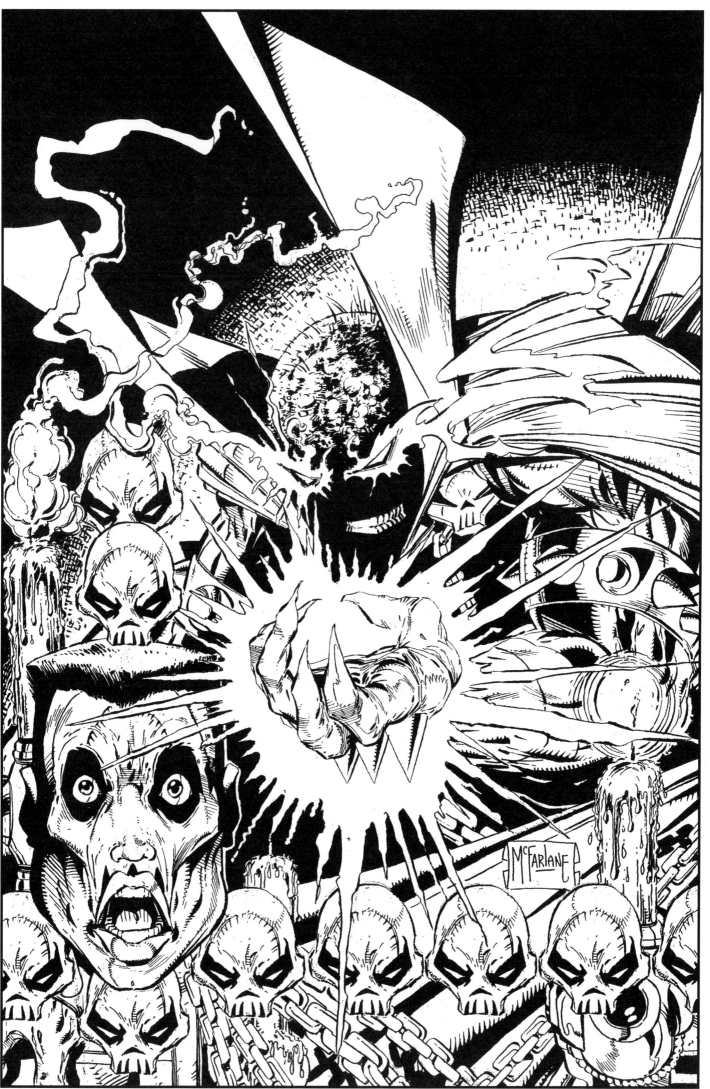

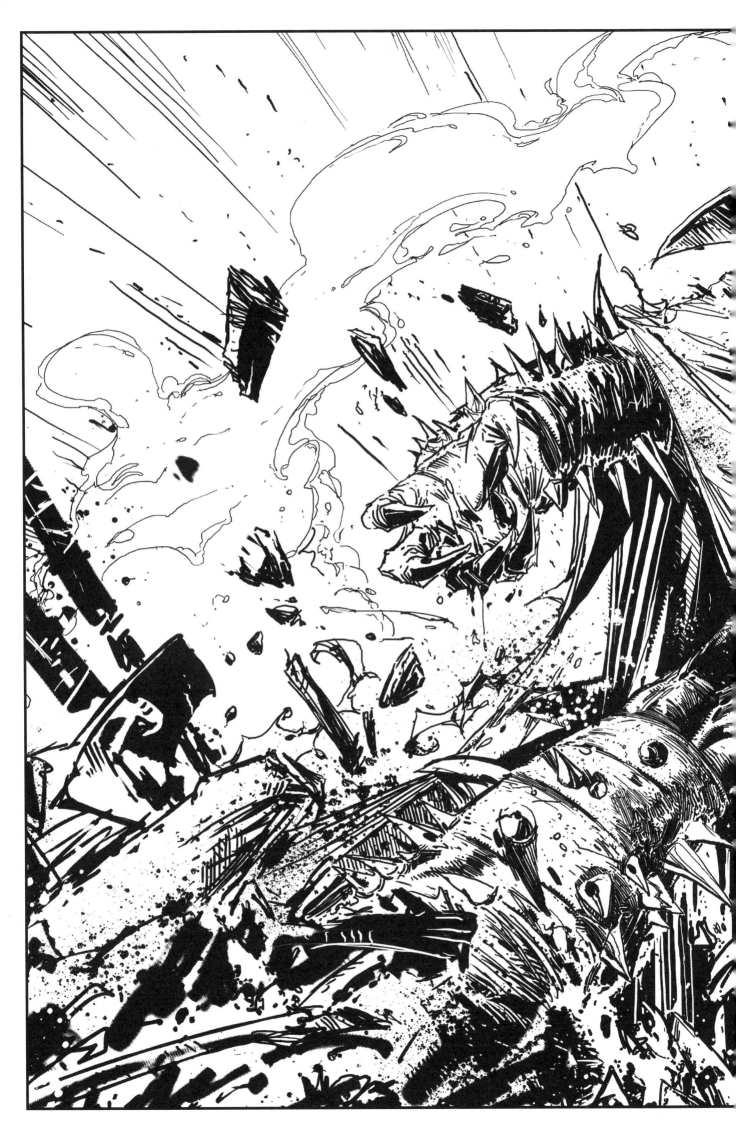

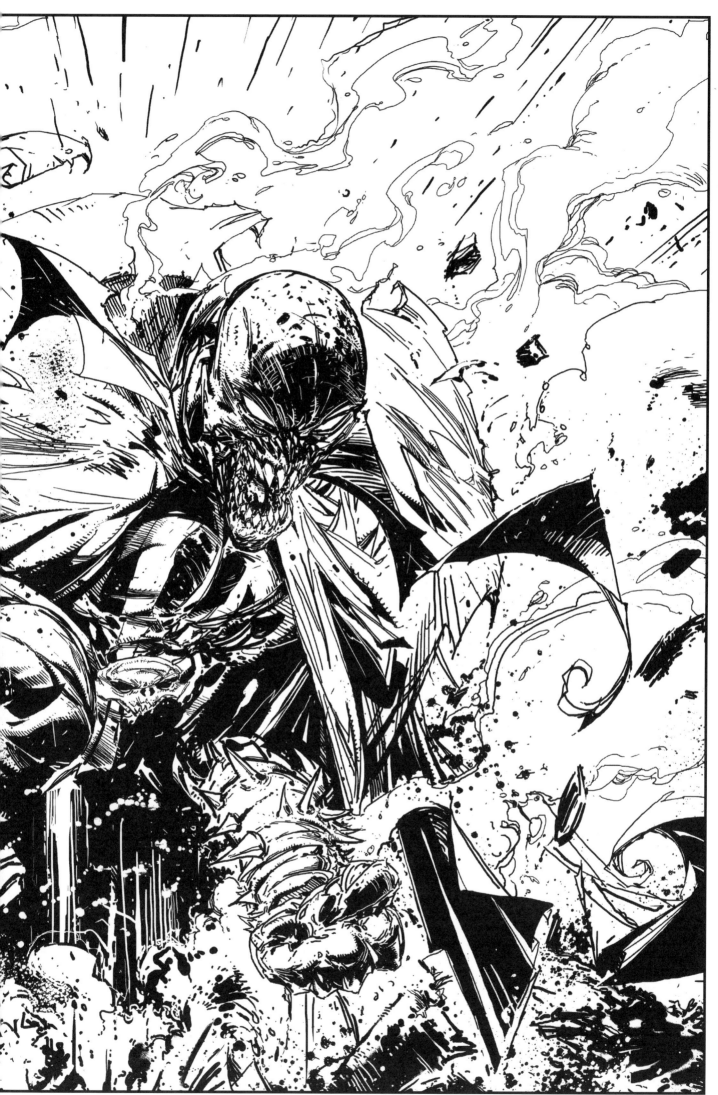

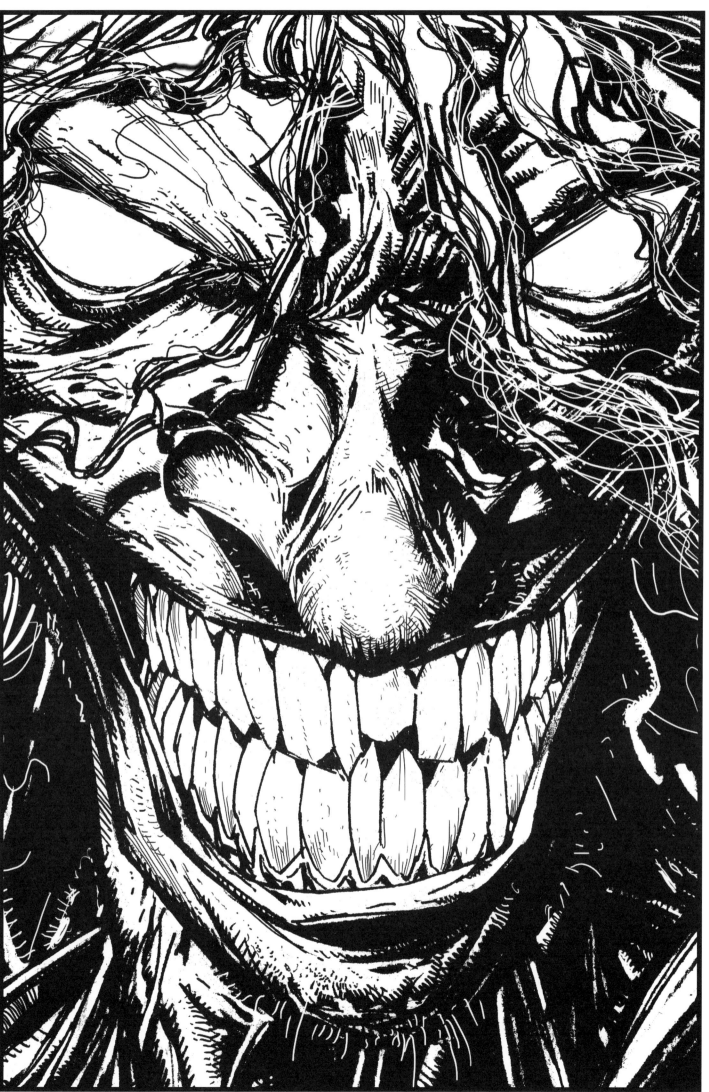